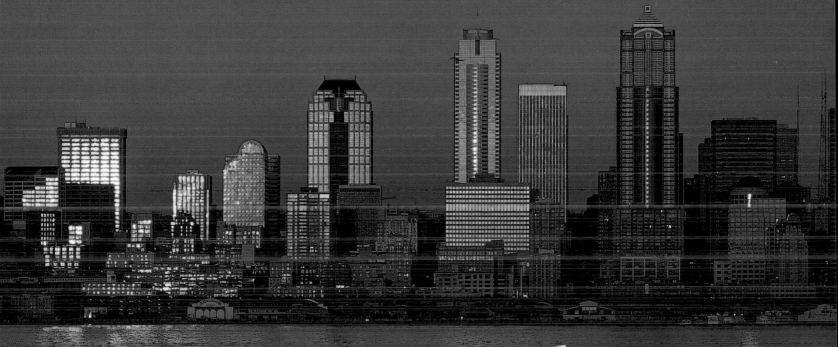

Seattle
impressions

FARCOUNTRY
PRESS

photography by **Charles Adams**

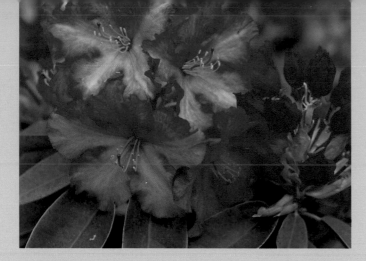

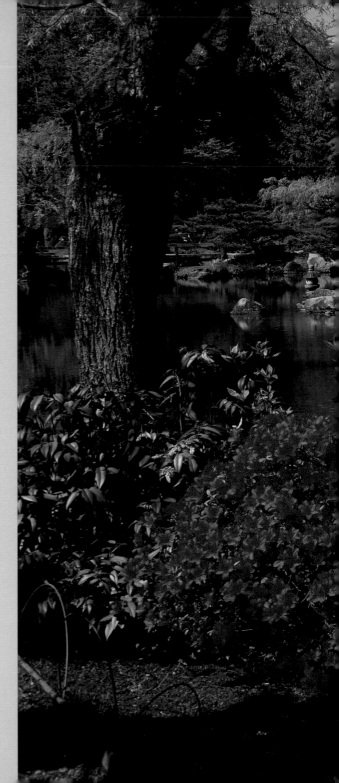

Above: The showy rhododendron is one of many plant species in 230-acre Washington Park Arboretum, founded in 1934 and managed by the University of Washington Botanic Gardens.

Right: The exquisite Japanese Gardens are popular with visitors to Washington Park Arboretum.

Title page: Sunset casts golden light on the Seattle skyline.

Cover: Founded in the 1850s, the city of Seattle is 54 miles northwest of Mount Rainier. At 14,411 feet, Mount Rainier is the highest peak in the Cascade Range.

Back cover: The Doris Chase sculpture *Changing Form* in Kerry Park frames a brilliant sunset. Kerry Park is know for its excellent vistas of the city, Elliott Bay, and Mount Rainier.

ISBN 10: 1-56037-381-4
ISBN 13: 978-1-56037-381-0

Photography © 2006 by Charles Adams
© 2006 Farcountry Press

For more information about our books write Farcountry Press, P.O. Box 5630, Helena, MT 59604; call (800) 821-3874; or visit www.farcountrypress.com.

Created, produced, and designed in the United States. Printed in China.

10 09 08 07 06 1 2 3 4 5

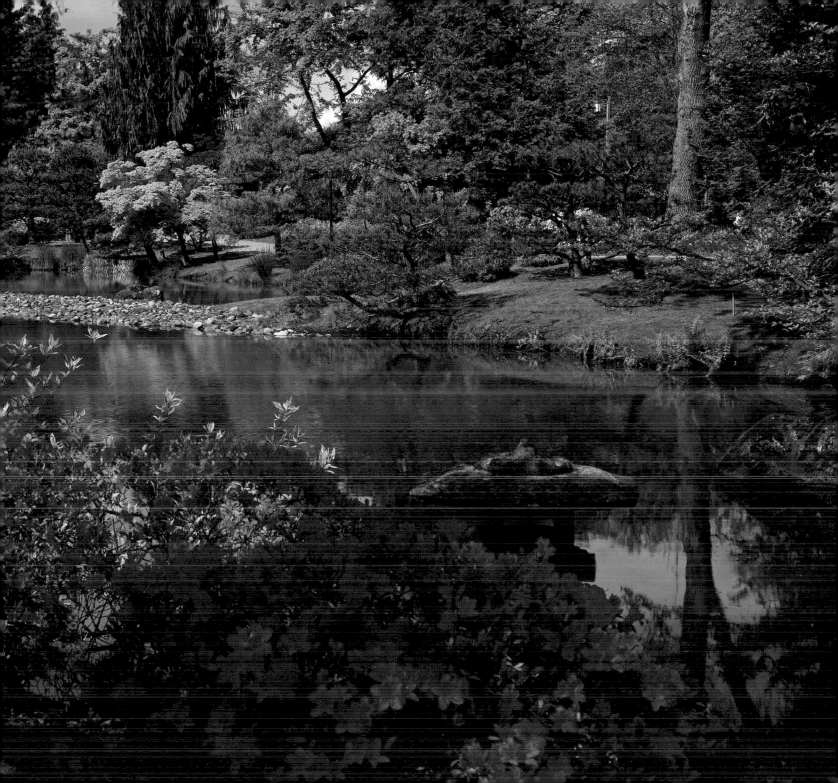

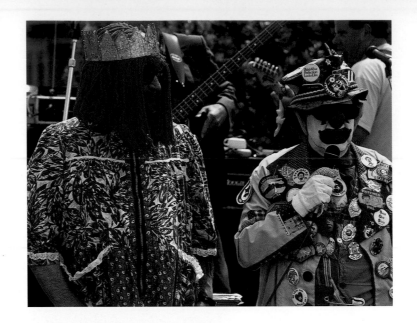

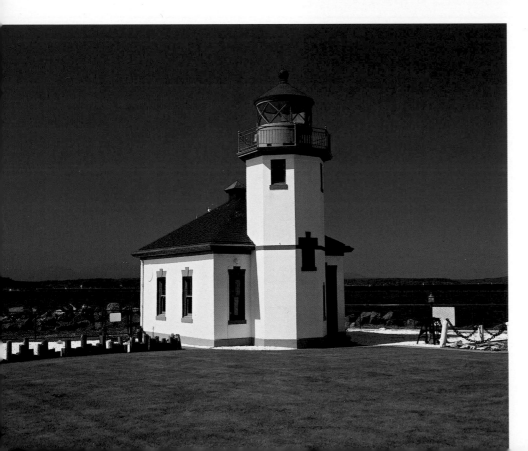

Above: From 1958 to 1981, beloved clown J. P. Patches *(right)* entertained Seattle children on his morning TV show. Here, he and fellow clown Gertrude greet fans.

Left: Completed in 1913, Alki Point Lighthouse makes its home at the southern entrance to Elliott Bay.

Right: The Victorian greenhouse at the Volunteer Park Conservatory is modeled after London's Crystal Palace and stands in Seattle's Capitol Hill neighborhood. Completed in 1912, the conservatory features a wide range of plants, including bromeliads, palms, ferns, and cacti.

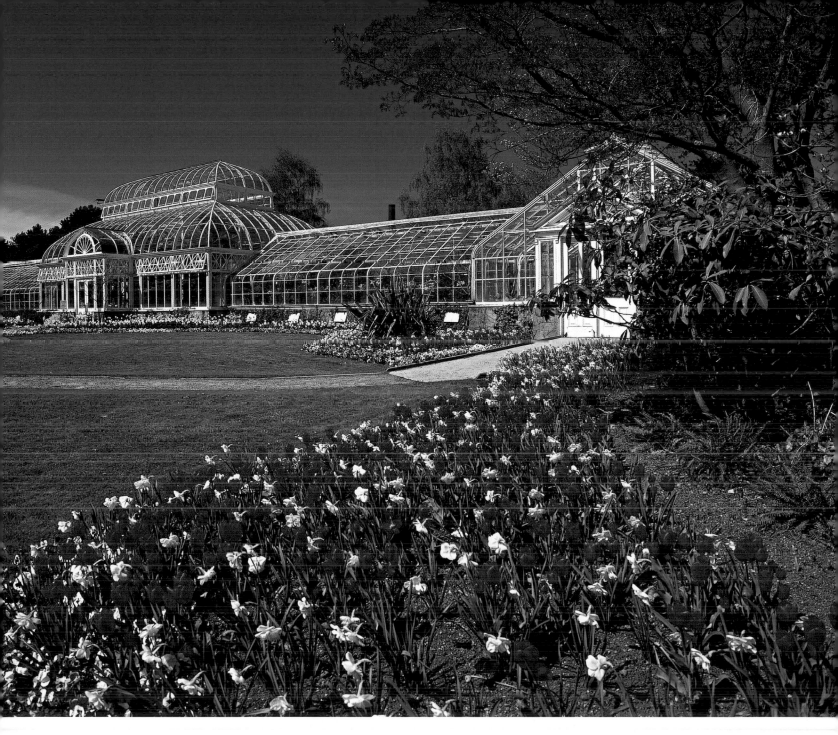

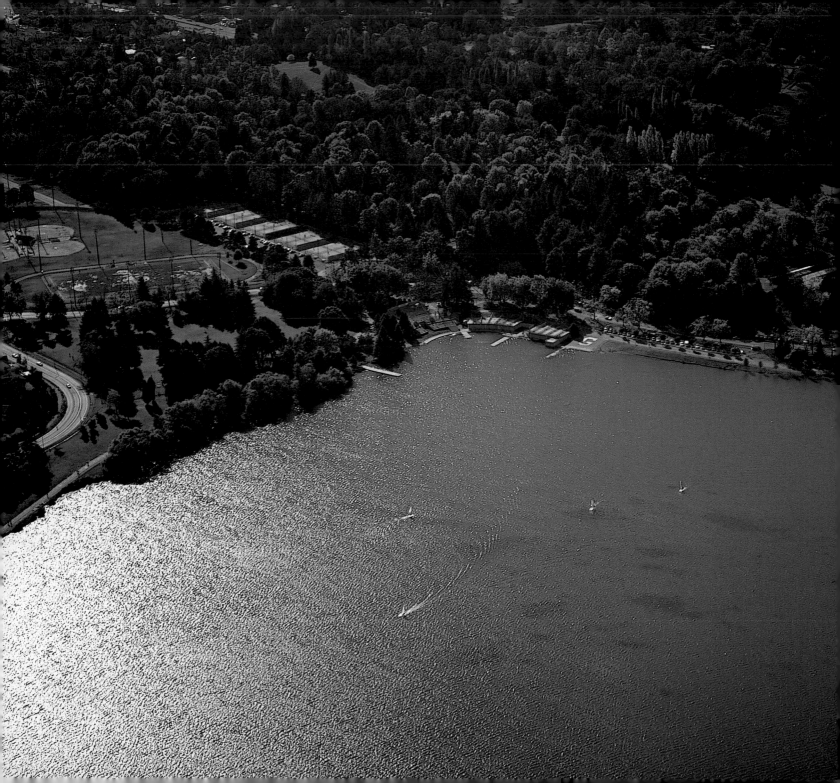

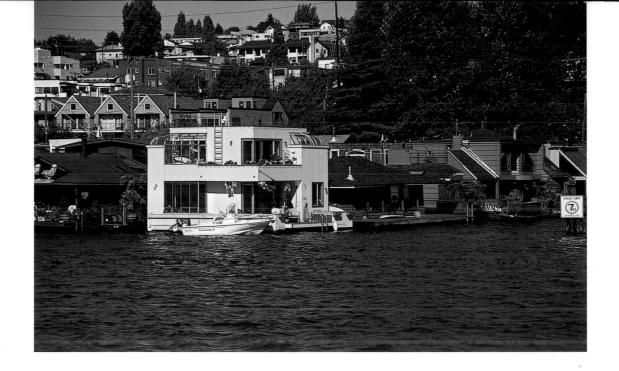

Above: Colorful boathouses line Lake Union.

Right: Crabbers and fishermen dock at Fisherman's Terminal after a hard day's work on Puget Sound.

Left: Fall color graces the shores of Green Lake, which offers abundant opportunities for recreation.

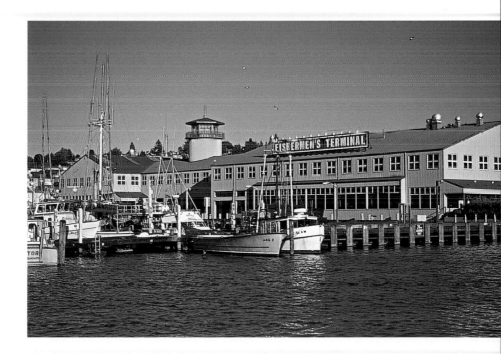

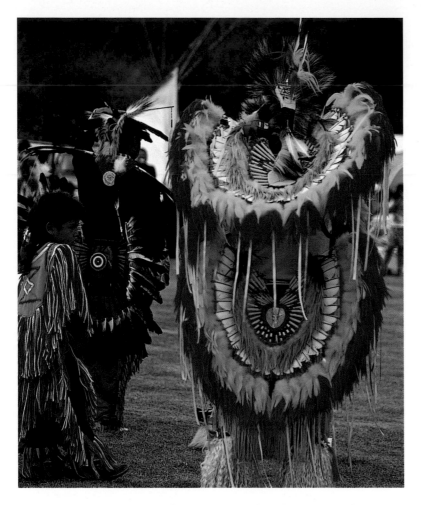

Above: Dancers don their colorful powwow regalia at Discovery Park.

Right: Visitors take in the salty air and enjoy the fine seafood
on Seattle's waterfront.

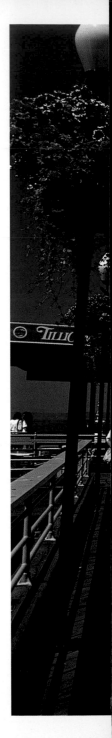

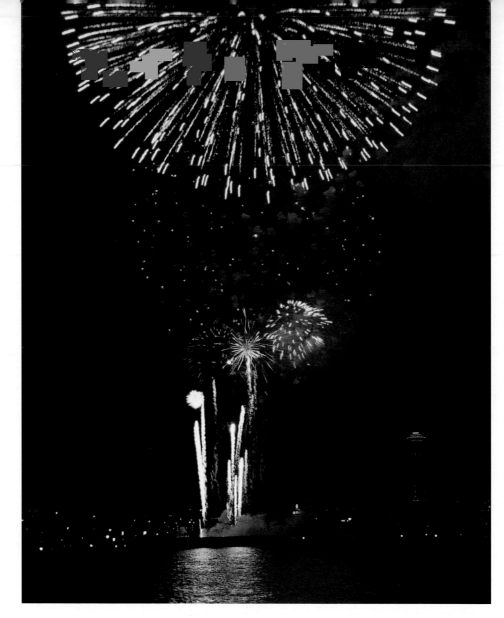

Above: Fireworks light up the night sky at the annual Fourth of July celebration on Elliott Bay.

Facing page: A Seattle fireboat tests its equipment in Elliott Bay.

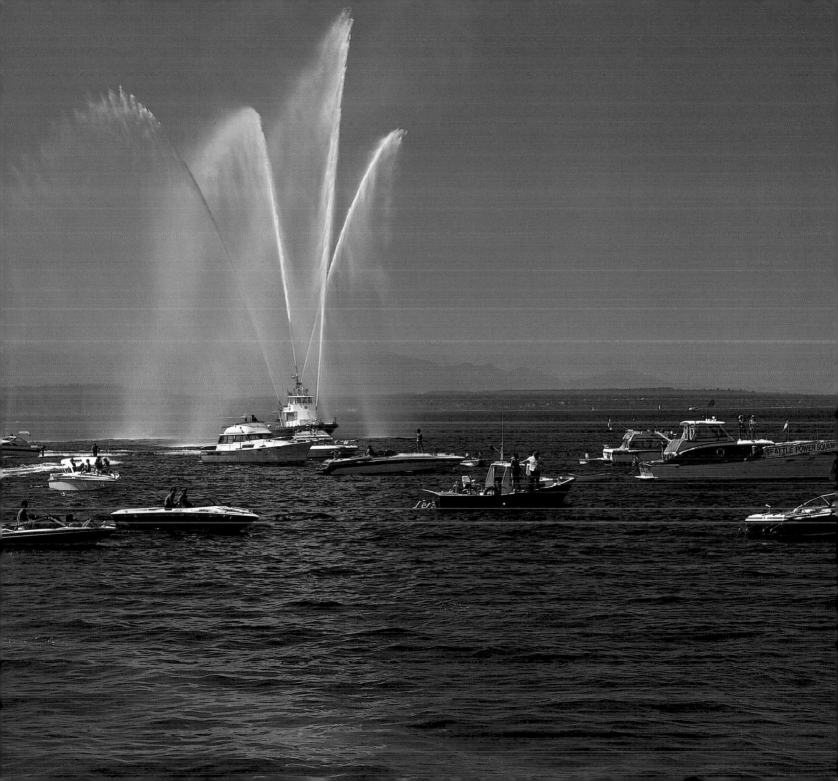

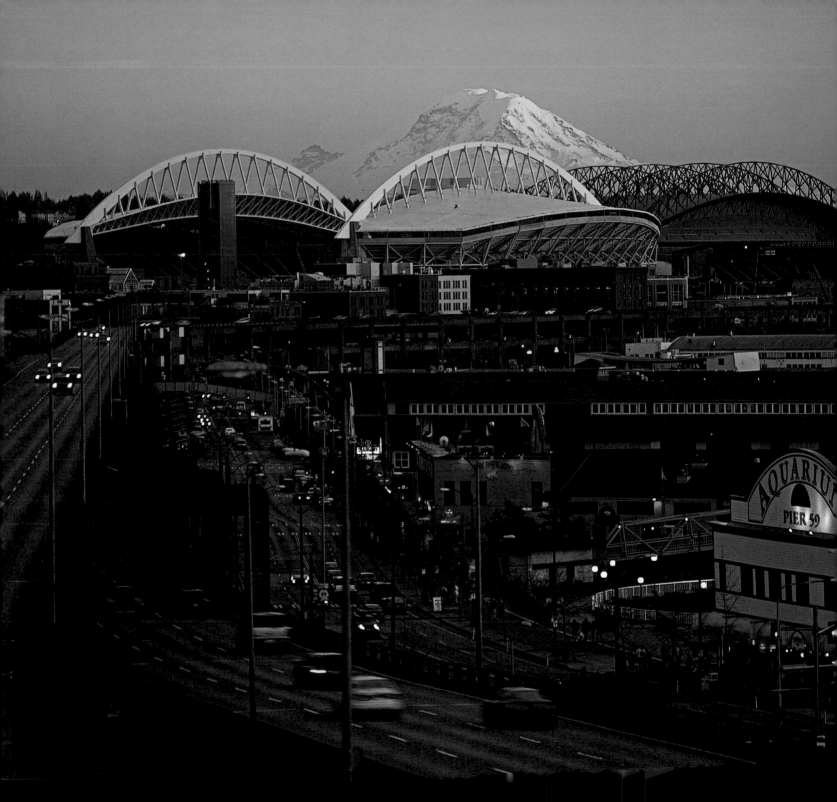

Left: Bordering Pioneer Square and the Chinatown–International District, Qwest Field is home of the NFL's Seattle Seahawks. Snow-capped Mount Rainier rises in the background.

Right: Sometimes called The Rainy City, Seattle averages about 226 cloudy days per year.
COURTESY JUPITERIMAGES CORPORATION.

Below: Horse-drawn carriages line up at Westlake Mall to take visitors around the city.

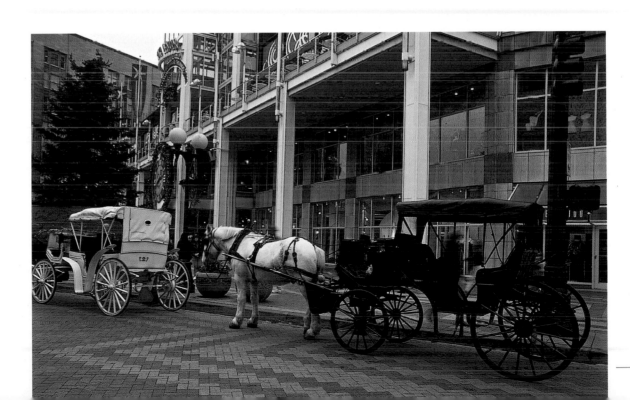

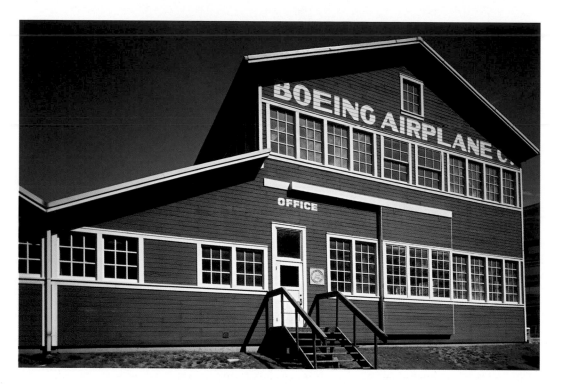

Above: Now part of Seattle's Museum of Flight, the building known as the Red Barn was the first home of the Boeing Company, founded in 1916.

Right: Tall ships make their way through Lake Union amid modern watercraft.

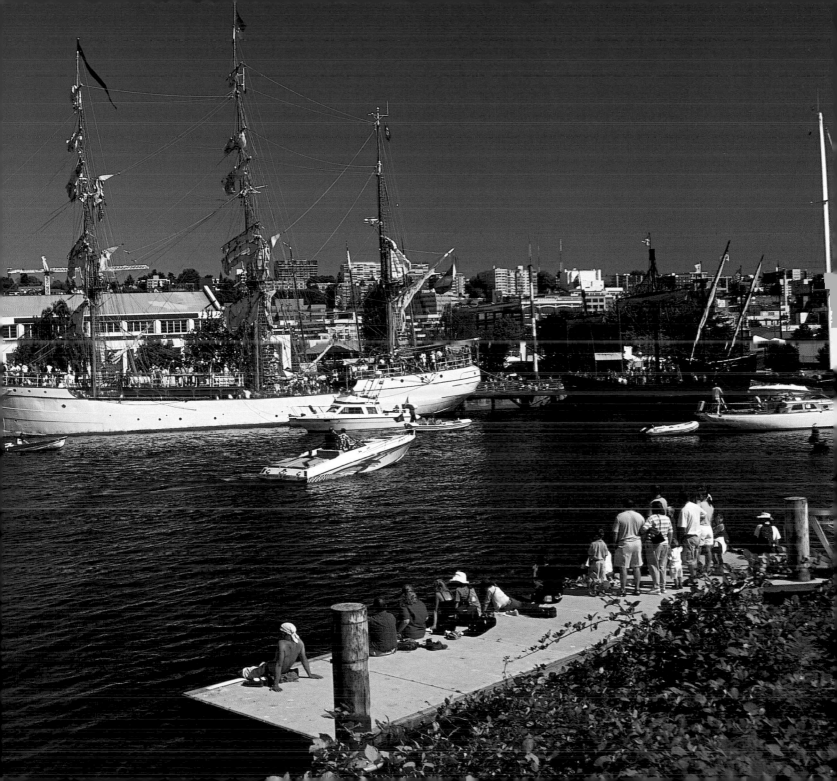

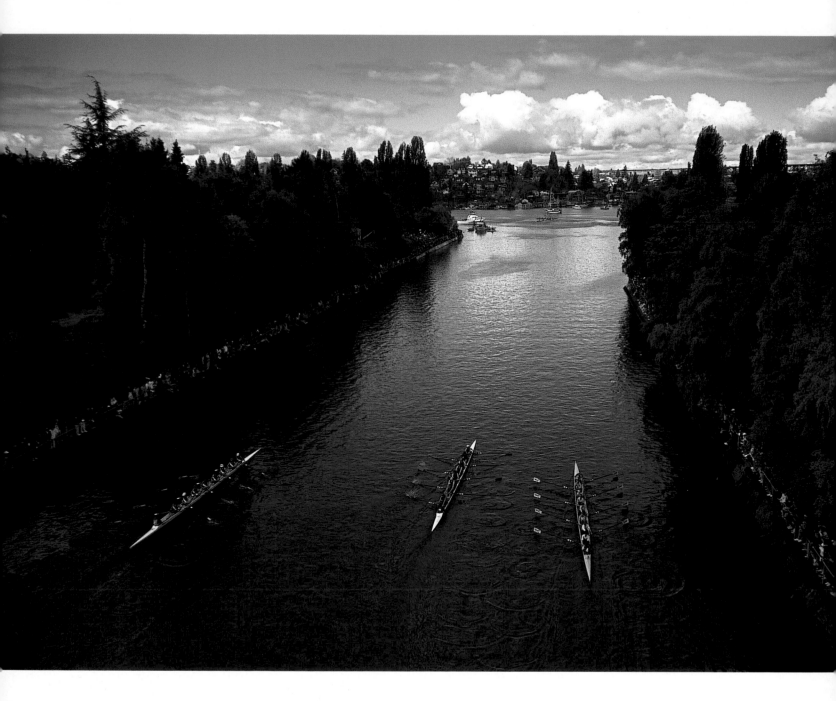

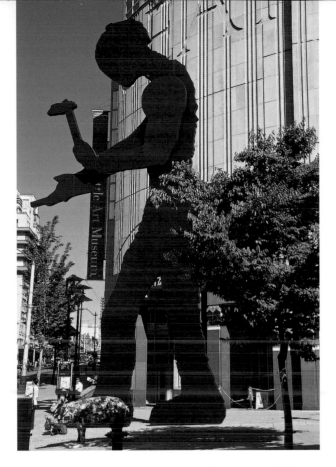

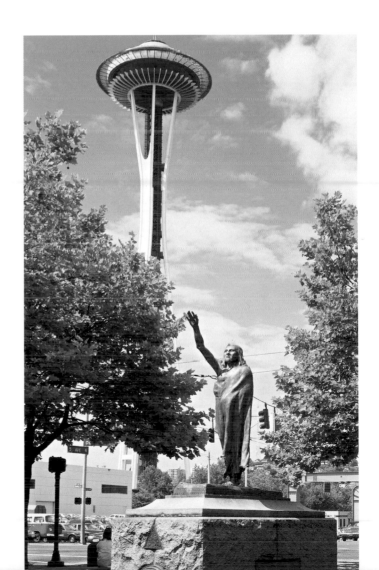

Above: Hammering Man was installed at the entrance of the downtown Seattle Art Museum in 1992. Artist Jonathan Borofsk created the 48-foot-tall, motorized sculpture in honor of workers everywhere. There are several other *Hammering Man* sculptures of various sizes throughout the world.

Right: In downtown Seattle in the shadow of the Space Needle stands a statue of Chief Sealth (known to settlers as Chief Seattle) of the Suquamish people. Created in 1912 by local sculptor James Wehn, the statue memorializes the controversial figure after whom the city is named.

Left: Spectators line the shores of the Montlake Cut as crew teams compete in the Windermere Cup.

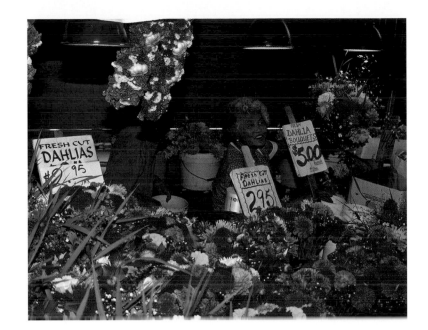

Left: Vendors offer a variety of fresh flowers at Pike Place Market.

Far left: Vibrant flowerbeds flank the entrance to the Seattle Asian Art Museum in Volunteer Park

Below: Extravagantly costumed young girls march in formation in the annual Chinatown International District Summer Festival

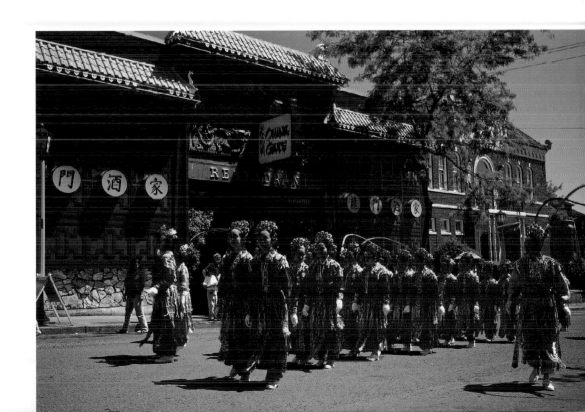

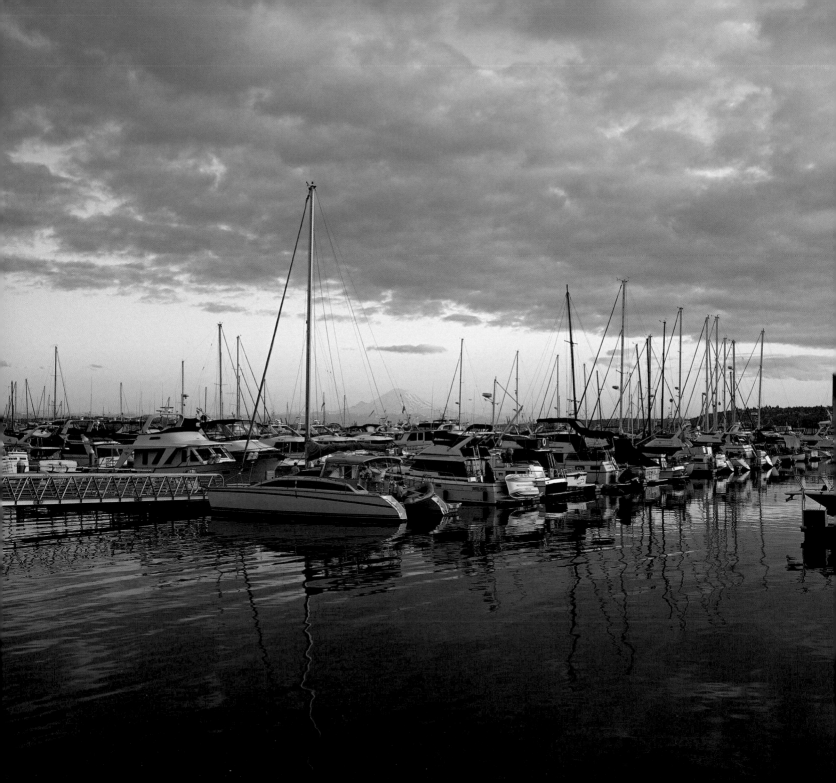

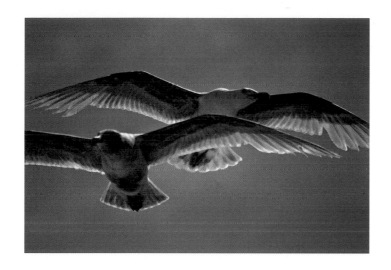

Left: Seagulls search the waterfront for a meal.

Far left: Boaters dock at popular Elliott Bay Marina.

Below: Ocean liners are loaded with cargo at the Port of Seattle.

Following pages: The bright pinnacle of the Space Needle crowns Seattle's luminous nighttime skyline.

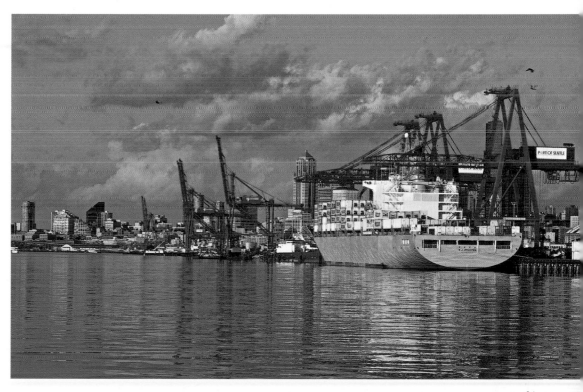

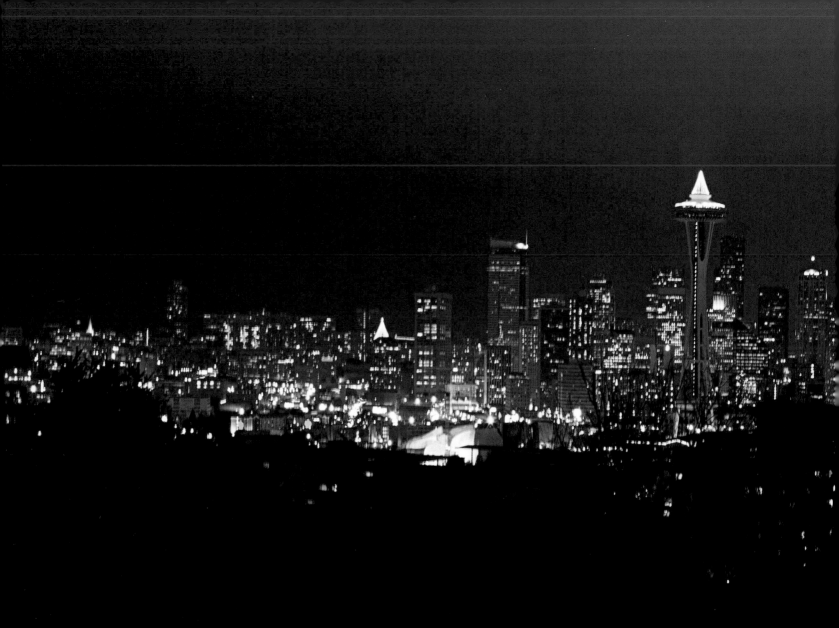

The 2.5-acre Woodland Park Rose Garden was opened in 1924 and features approximately 280 different varieties of roses and more than 5,000 individual plants.

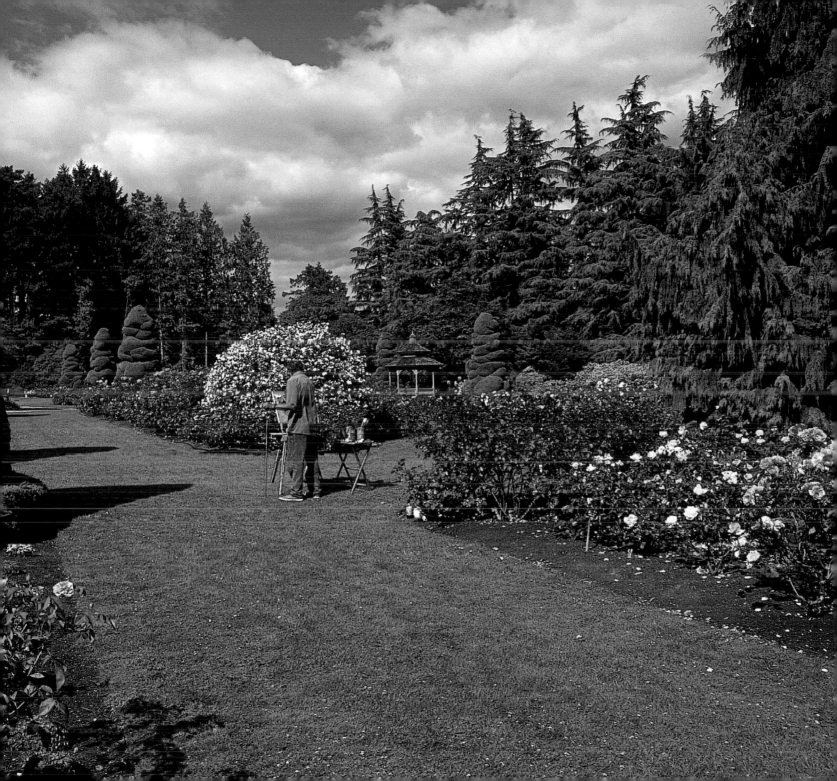

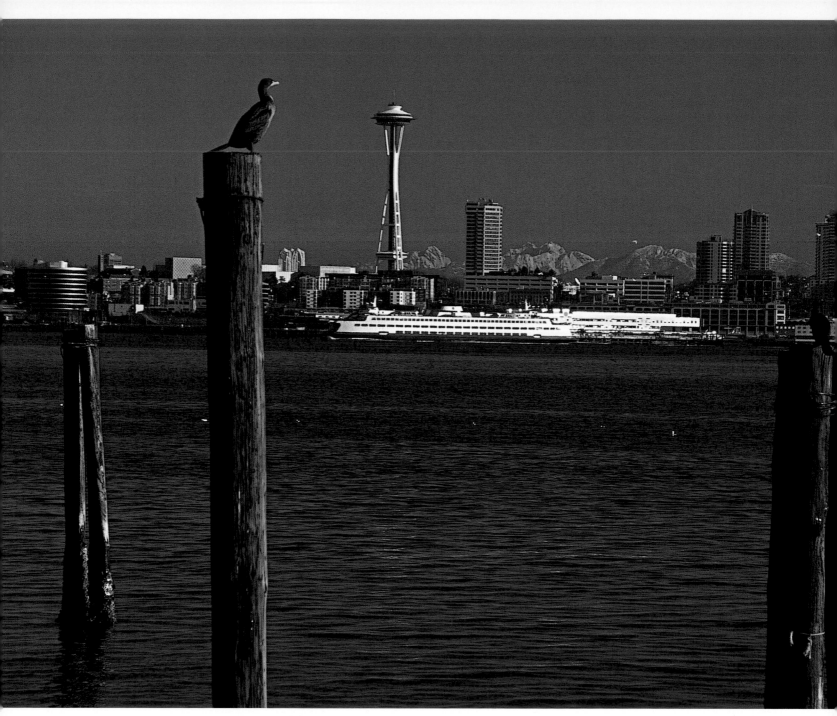

Left: Seabirds perch atop pilings in Puget Sound across Elliott Bay from downtown Seattle, with the Cascade Range in the distance.

Below: Totem poles adorn Pioneer Square, a city park dedicated to Seattle's early history. Turn-of-the-century street lamps line the square, and at night the area's taverns and eateries draw large crowds.

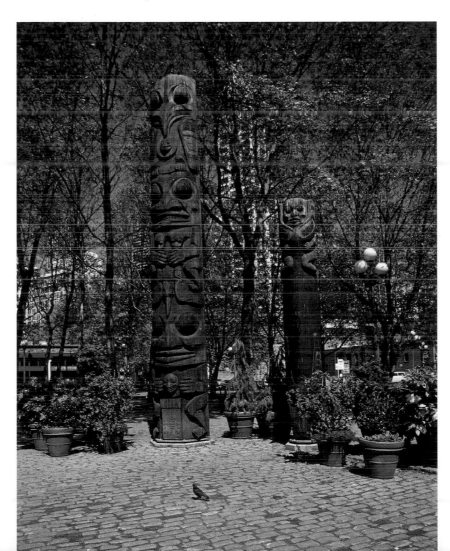

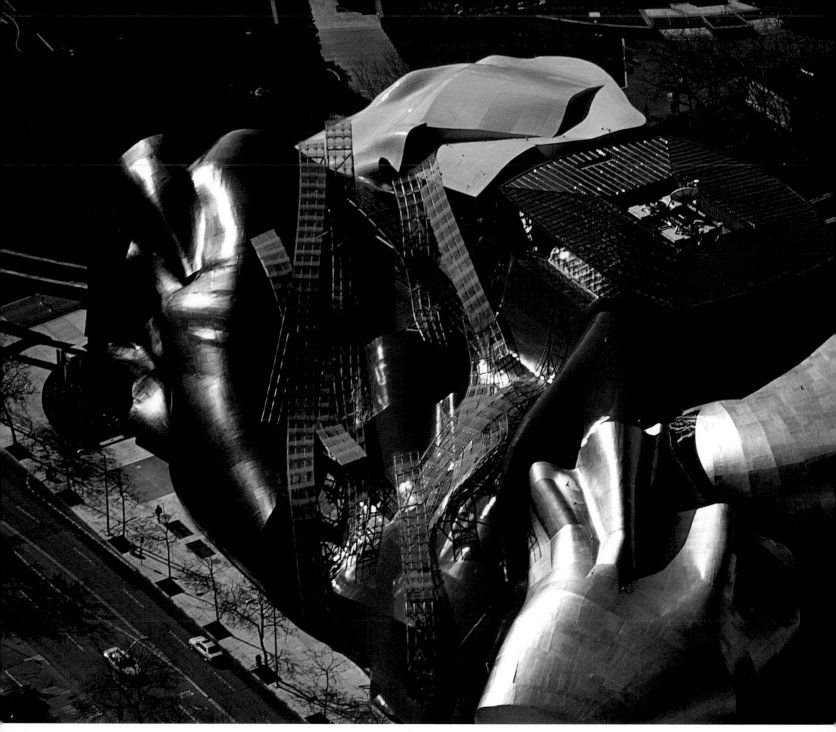

Left: One of Seattle's most recognizable landmarks, the Experience Music Project opened in 2000. Created by Paul Allen and Jody Patton, EMP features more than 100,000 legendary music artifacts, an extensive Jimi Hendrix memorabilia collection, and interactive sound labs that encourage visitors to unleash their inner rock star.

Below: Competitors take to Green Lake for the Milk Carton Derby, just one of many popular events at Seattle's annual Seafair, which began in 1950.

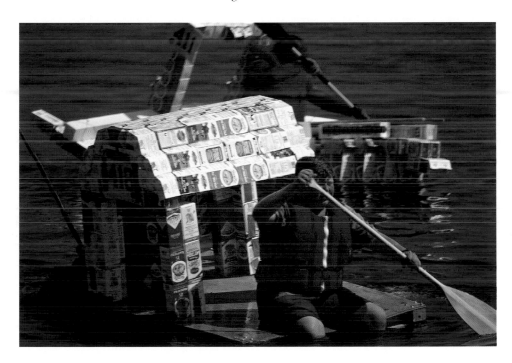

Above: Born in Seattle on November 27, 1942, Jimi Hendrix was both an influential musician and a cultural icon. He died in 1970 at age 27 and is buried in Greenwood Memorial Park in Renton.

Right: Alki Point juts out into Puget Sound and is the westernmost point in West Seattle.

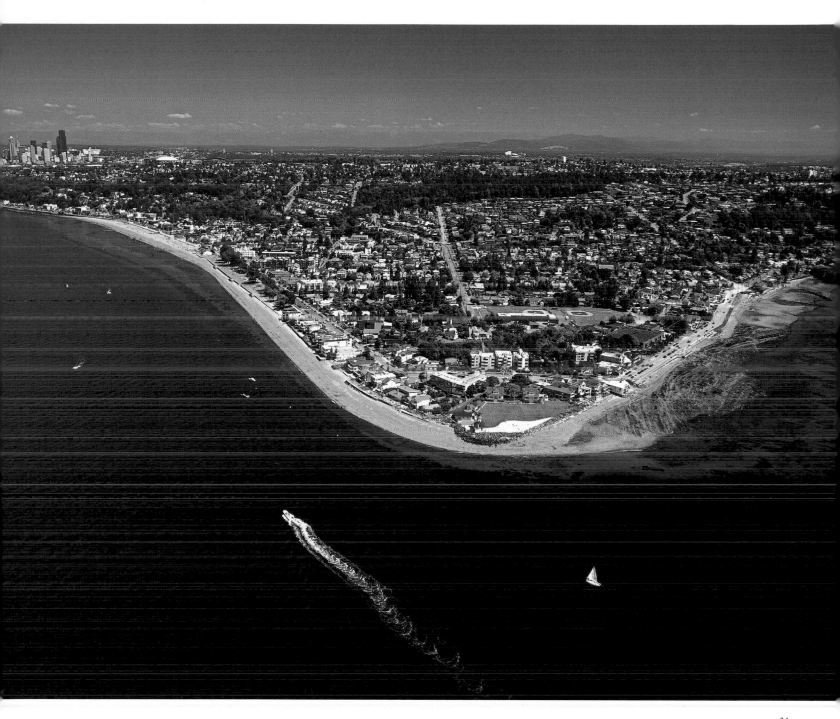

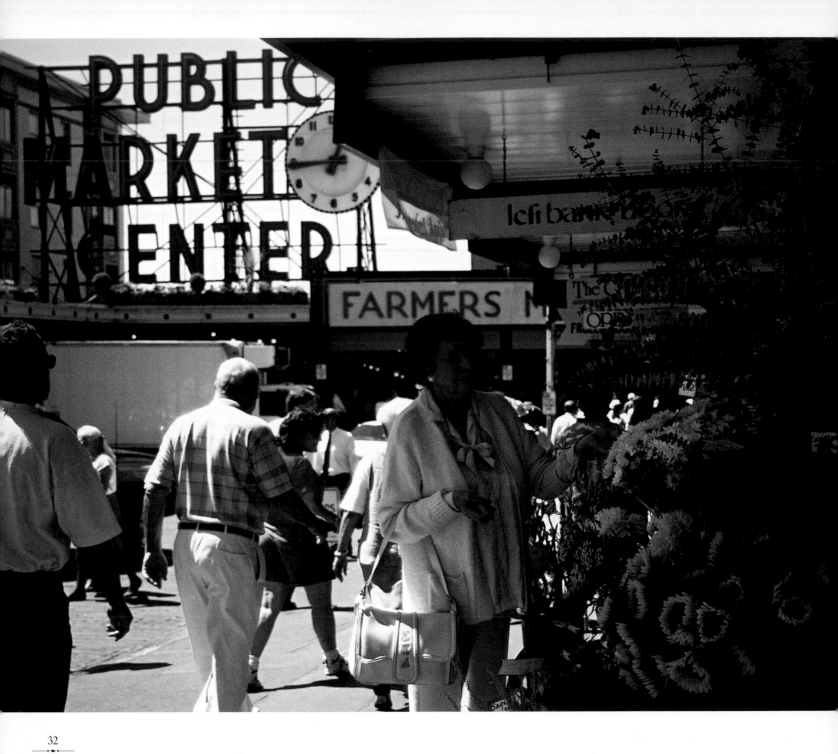

Pike Place Market—known for its entertaining fishmongers who wow crowds with flying seafood—occupies nine acres on Seattle's waterfront. In 1907, Councilman Thomas Revelle created a public street market to sidestep price-gouging middlemen and put farmers and consumers in direct contact. Today, more than 10 million people annually visit Pike Place Market, which is recognized as the country's premier farmers' market.

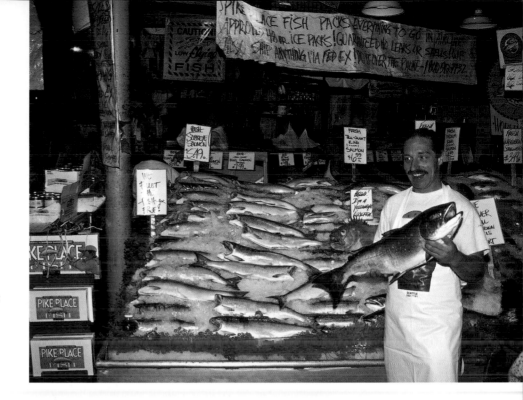

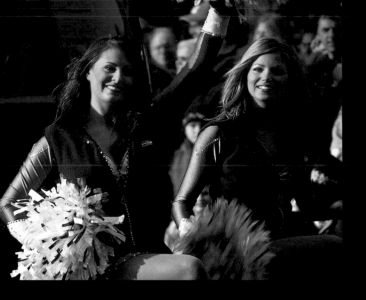

Left: Two Sea Gals, cheerleaders for the Seahawks, wave to fans at Seafair's Torchlight Parade.

Facing page: Fireworks mark a win for the Seahawks, as they pour onto the field to celebrate. COURTESY SEATTLE SEAHAWKS.

Below: Completed in 1999, Safeco Field is home of the Mariners. In order to maintain an open-air feel, the unique retractable roof is designed to cover but not enclose the park. COURTESY SEATTLE MARINERS.

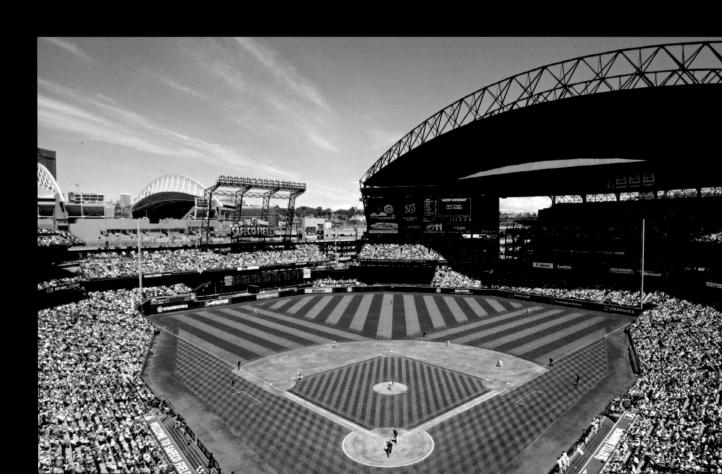

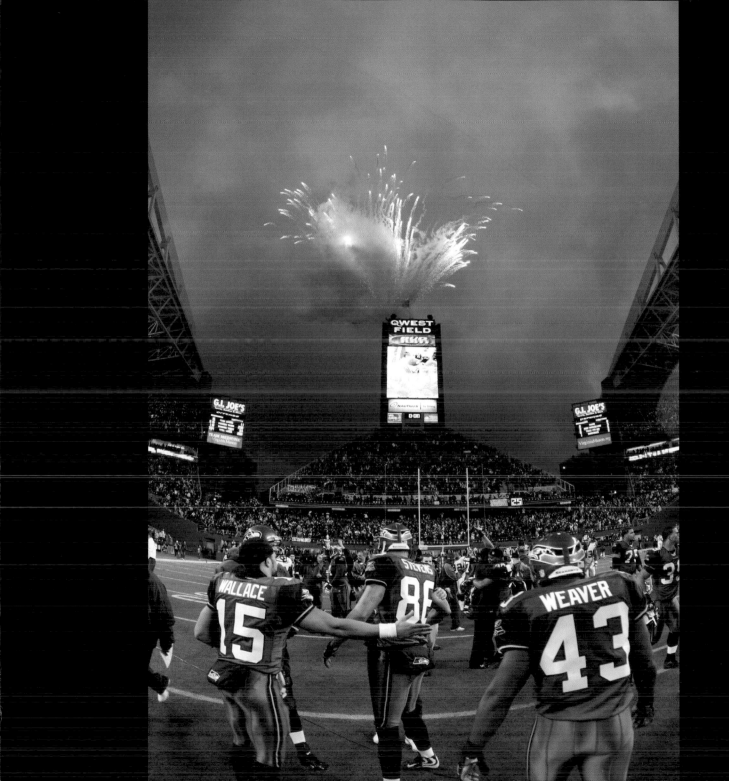

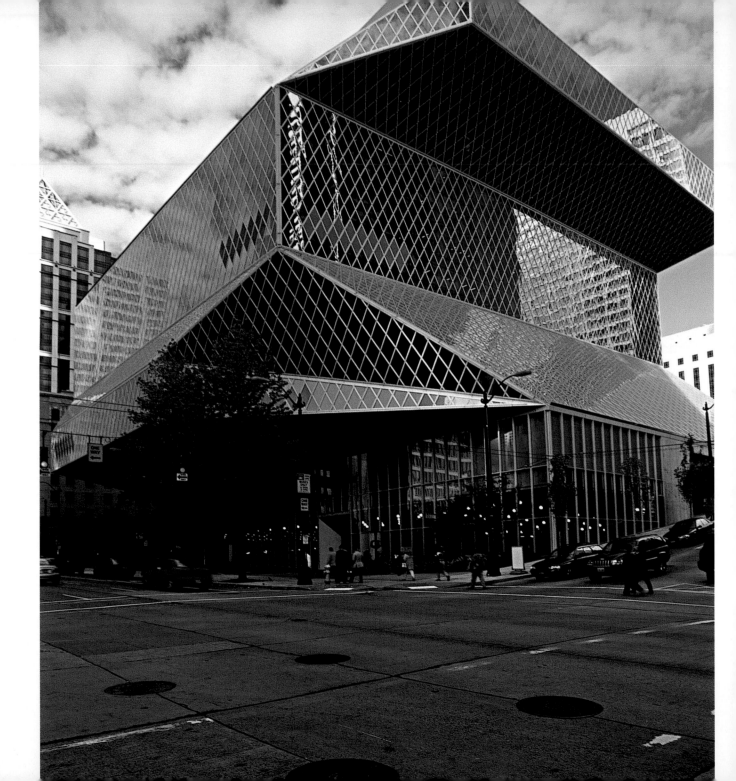

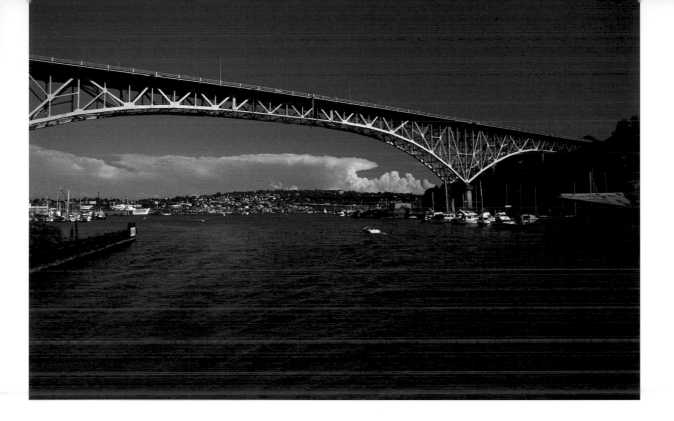

Above: The Aurora Bridge, the first major highway bridge built in Seattle, was completed in 1932. The cantilever bridge spans the west end of Lake Union.

Facing page: Seattle's 11-story Central Library occupies 362,987 square feet and features a unique diamond-patterned exterior skin of glass and steel.

Right: Popular with visitors, the Ballard Locks are located along the Lake Washington Ship Canal and allow vessels to pass from Lake Washington into Puget Sound.

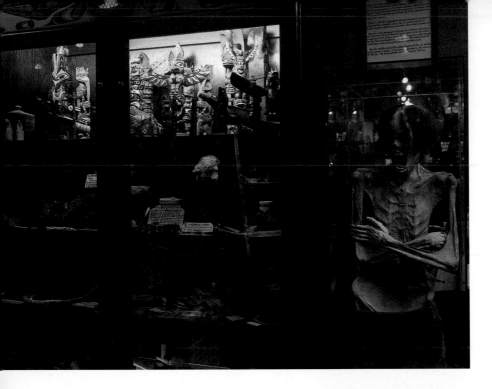

Left: J. E. "Daddy" Standley founded Pier 54's Ye Olde Curiosity Shop in 1899. A Seattle landmark, the shop features a mummy named Sylvia, shrunken heads, the Lord's prayer engraved on a grain of rice, a six-foot crab, and much more.

Facing page: Opened in 1952, the Museum of History and Industry is home of the 1950 U-27 Slo-mo-shun IV hydroplane, which set the world water speed record on Lake Washington in 1950.

Below: Visitors donate their spare change to Rachel, Pike Place Market's 550-pound bronze piggybank. The money has helped fund the Market Foundation since 1986.

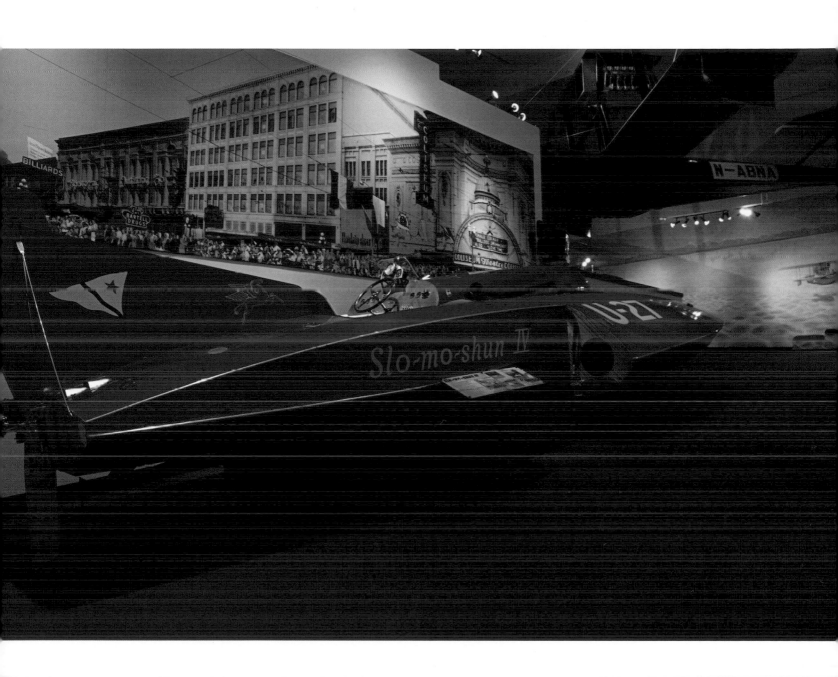

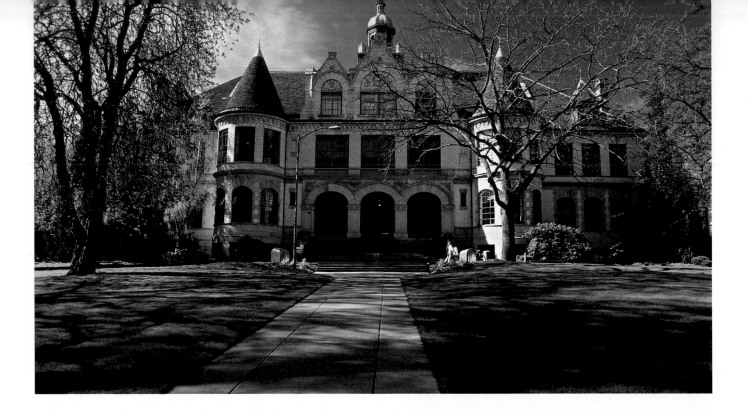

Above: Built in 1895, Denny Hall is the oldest building on the University of Washington campus. It is named after Seattle pioneers Alfred and Mary Denny, who donated land to the university for its original site.

Right: A yacht slices through the Montlake Cut, the eastern-most section of the Lake Washington Ship Canal. The Cut connects Lake Washington's Union Bay and Lake Union's Portage Bay.

Facing page: A Seattle landmark, the 514-foot Rainier Tower was completed in 1977. The 29-story structure rests on a narrow, 11-story pedestal.

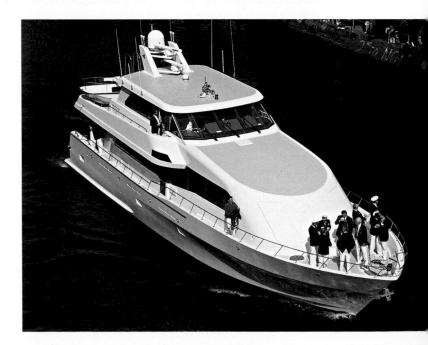

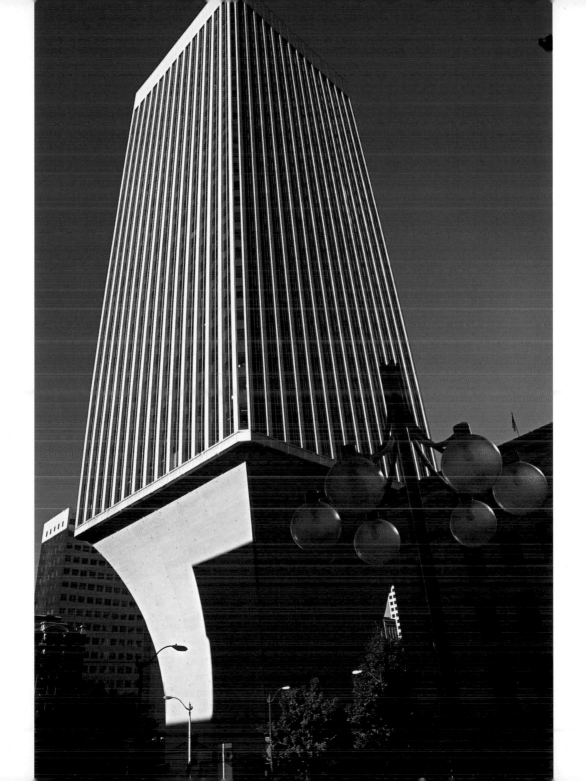

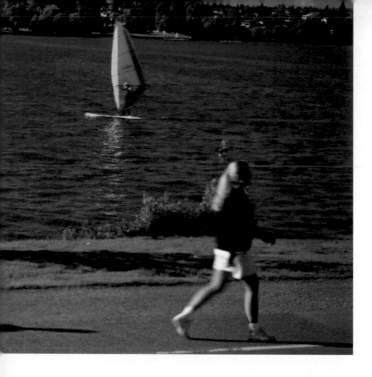

Left: One of Seattle's most beloved parks, Green Lake Park offers picnic areas, athletic fields, several miles of paths, and plenty of opportunities for water recreation.

Right: Alki Beach is jam packed for Seafair, the largest festival in the Northwest. Seafair events include a triathlon, air show, parade, and hydroplane races, just to name a few.

Below: Traveling on the Elliott Bay Water Taxi is a great way to avoid the vehicle traffic between the waterfront and West Seattle.

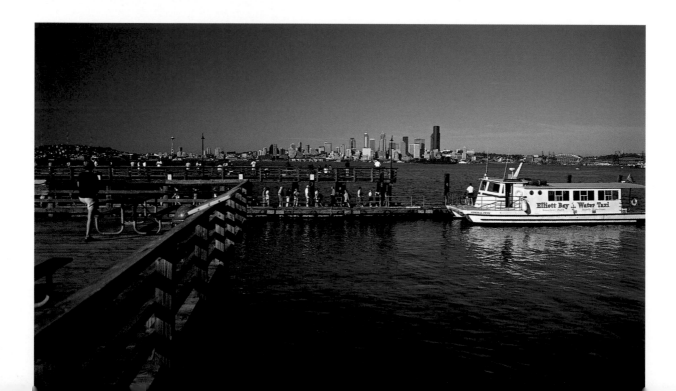

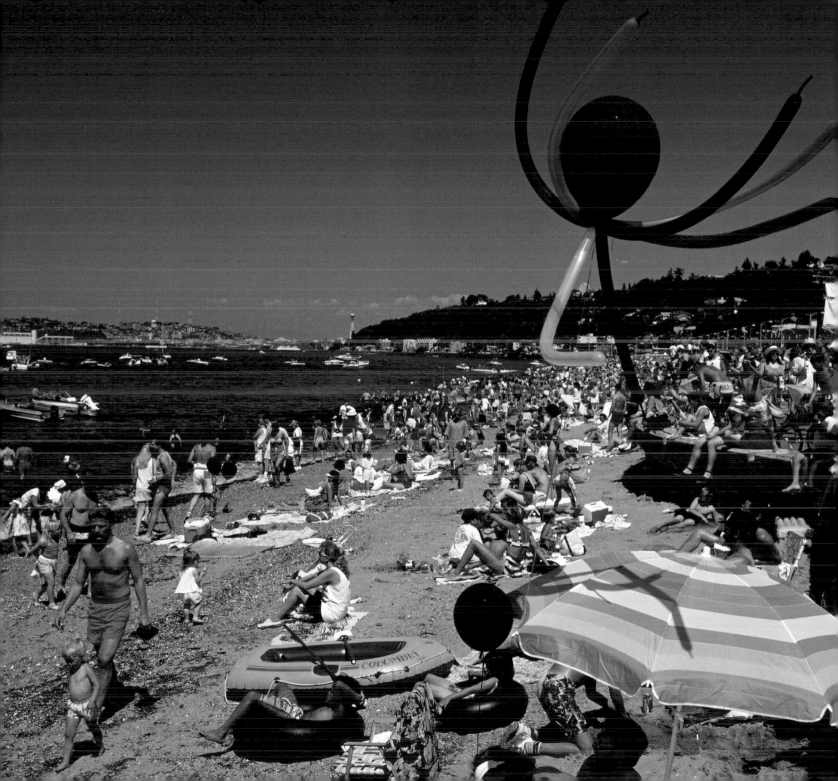

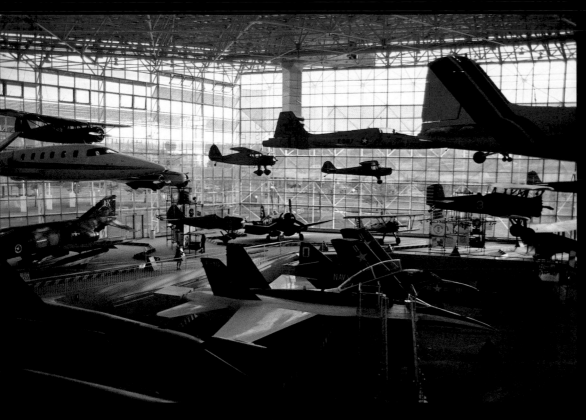

Above and right: One of the largest air and space museums in the world, the non-profit Museum of Flight attracts nearly a half million visitors annually. Its collection includes more than 150 air- and spacecraft, and it features the largest aviation and space library and archives on the west coast.

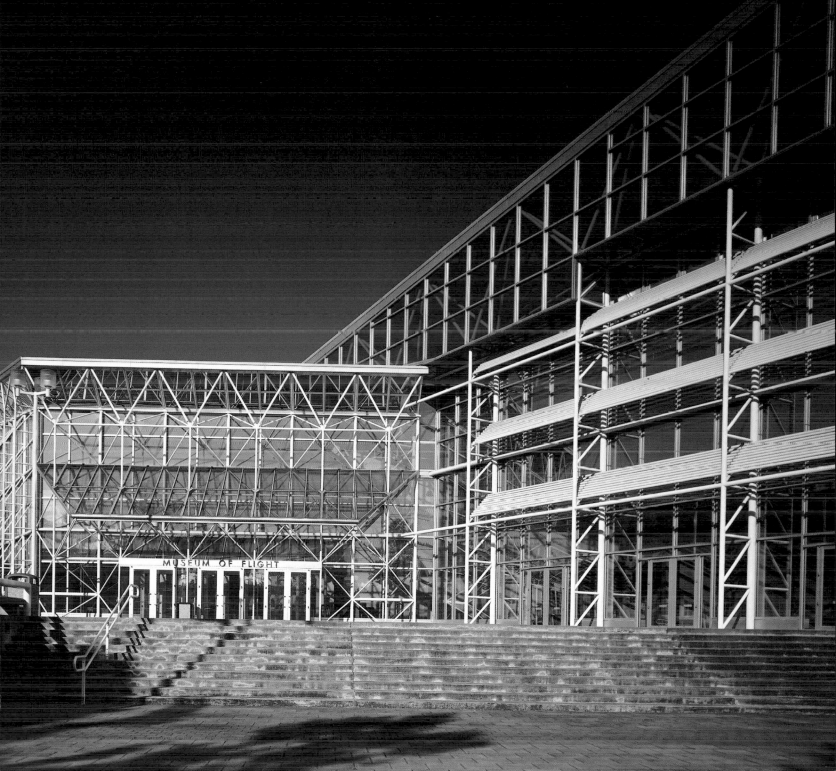

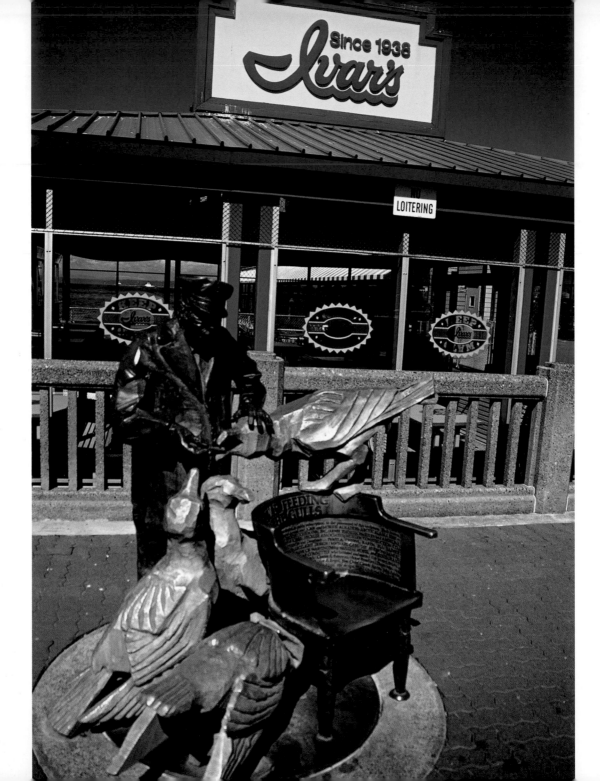

Above: Located on Pier 59 on the waterfront, the Seattle Aquarium offers hands-on exhibits for those wanting to learn more about the marine life of the Pacific Northwest.

Facing page: Ivar Haglund opened Seattle's first waterfront aquarium in 1938. To serve those hungry visitors, he opened a small fish-and-chips restaurant called Ivar's Acres of Clams, which has become simply Ivar's. Near the entrance to this Seattle institution is a statue of Haglund feeding the gulls.

Left and below: Located on the grounds of the Seattle Center, the Space Needle rises to a height of 605 feet. At 520 feet, the observation deck affords stunning 360-degree views of the city. Both the Space Needle and the Seattle Monorail *(below)* were built for the 1962 World's Fair. The monorail carries passengers between the Seattle Center and downtown.

Facing page: The 76-story Columbia Center building, the black skyscraper in the foreground, was completed in 1985 and is the tallest building in Washington state. It is also the tallest building (in number of floors, 76) west of the Mississippi River.

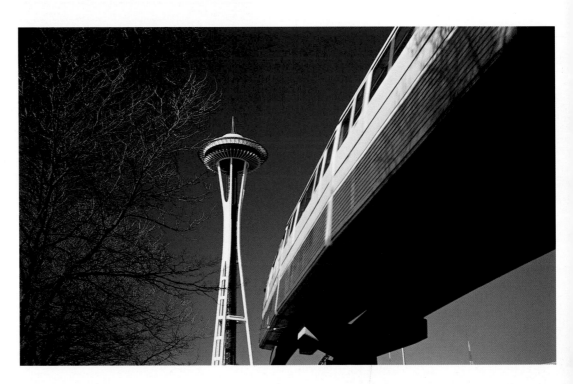

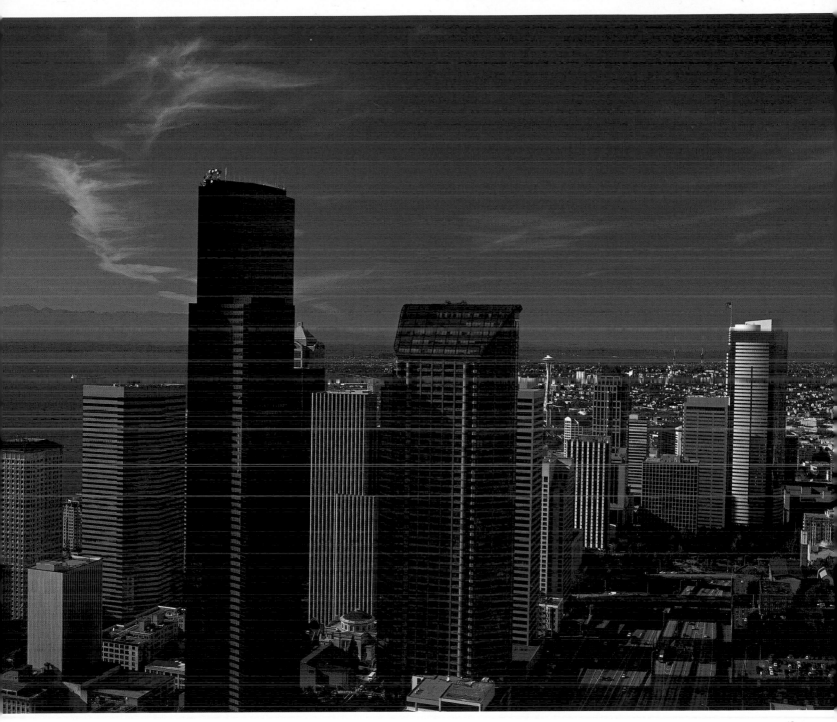

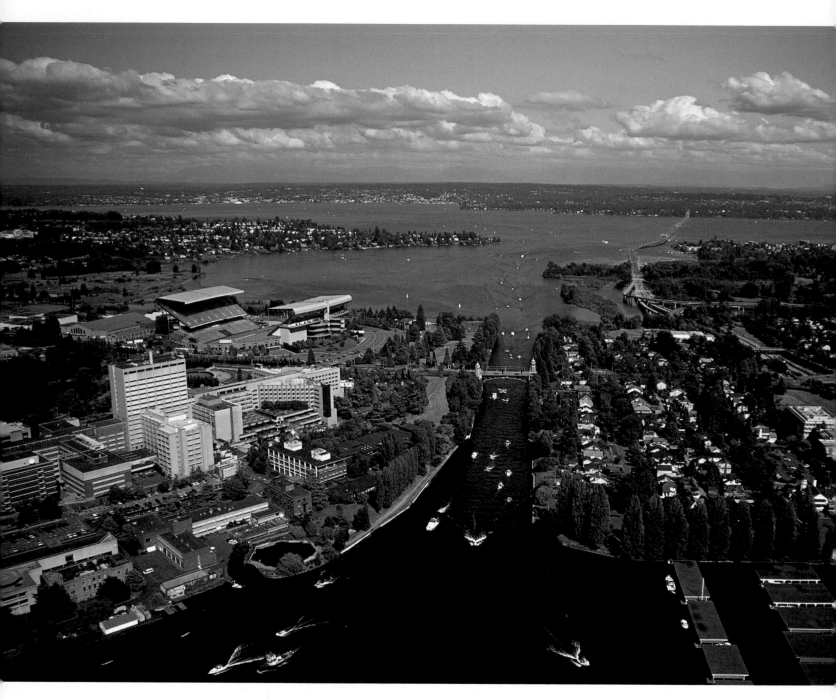

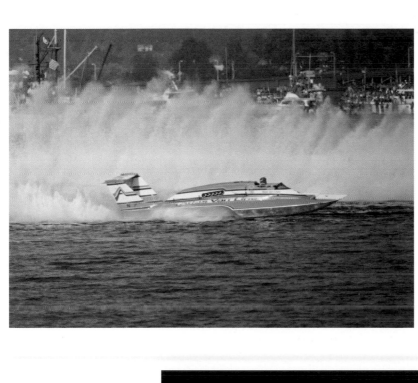

Left: Local hero Bill Muncey helped drive the popularity of hydroplane racing in the 1960s, when he won many trophies and set numerous records.

Far left: Boats file through the Montlake Cut, which flows past the University of Washington campus.

Below: Hydroplane racers ready their watercraft in the Stan Sayres Pit on Lake Washington.

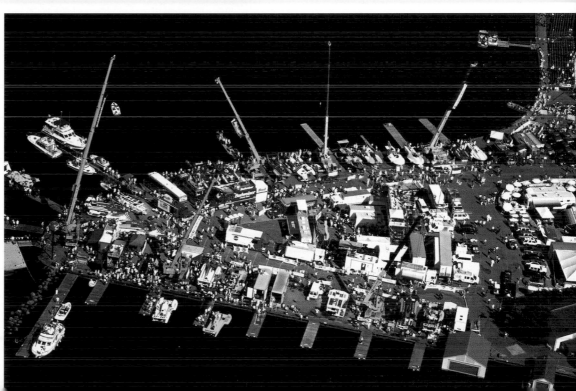

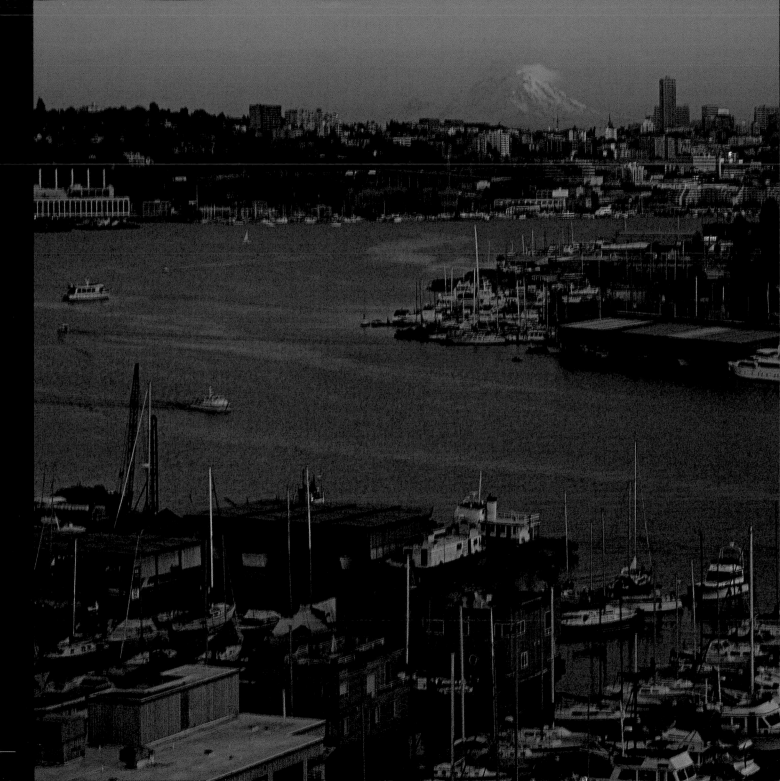

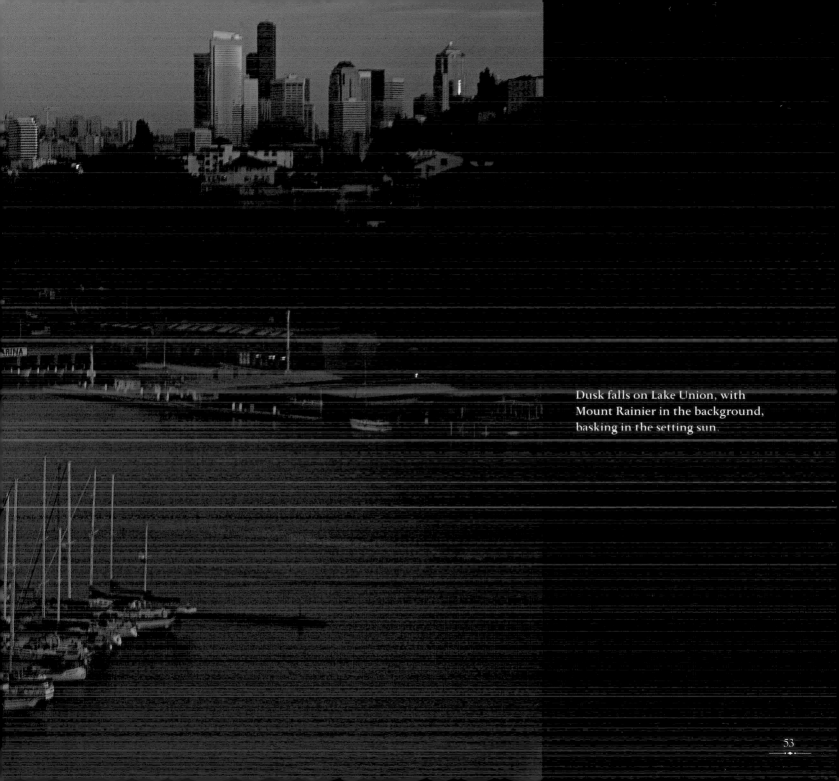

Dusk falls on Lake Union, with Mount Rainier in the background, basking in the setting sun.

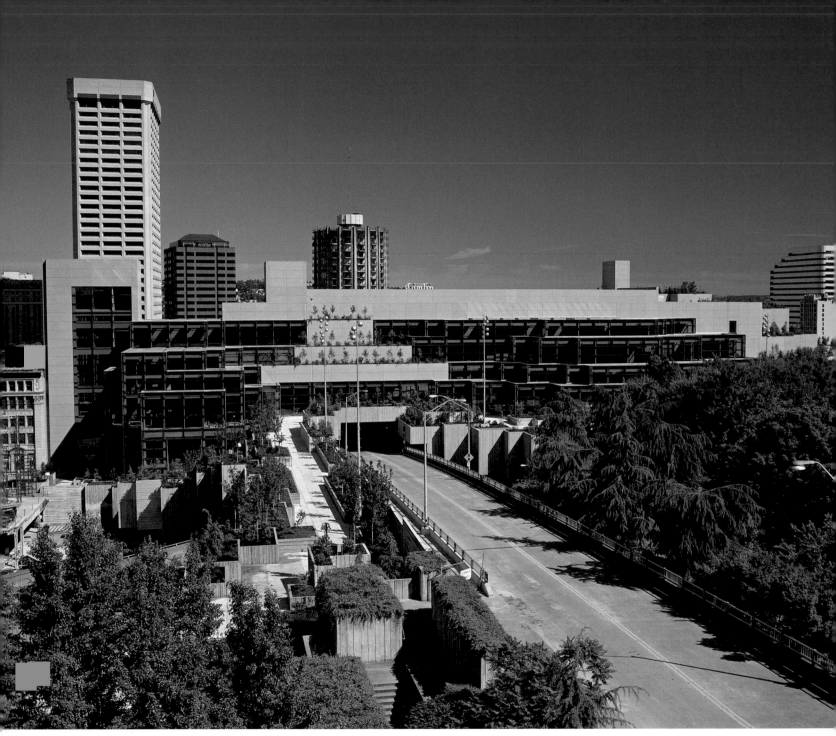

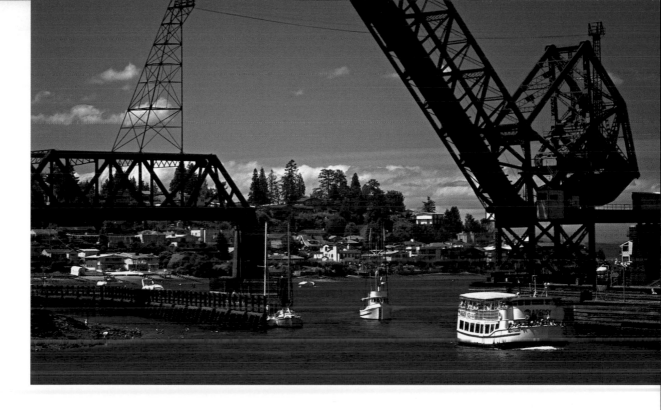

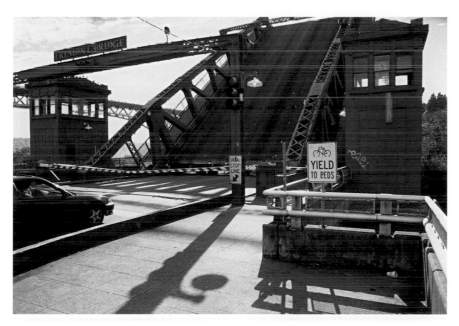

Above: The *Argosy* passes under the Ballard Railroad Bridge, which spans the Lake Washington Ship Canal on the west side of the Ballard Locks.

Left: Opened in 1917, the Fremont Bridge crosses the Lake Washington Ship Canal and connects the neighborhoods of Fremont and Queen Anne.

Far left: The Washington State Convention and Trade Center was built over Interstate 5. Completed in 1988, the center boasts more than 200,000 square feet of exhibit space.

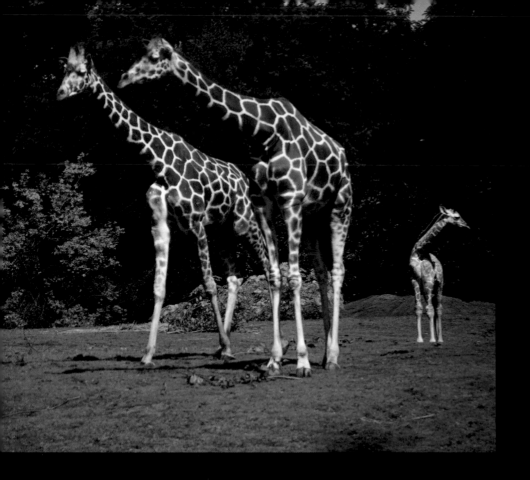

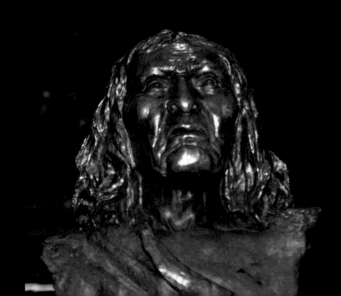

Above: Giraffes are among the many exotic animals that make the Woodland Park Zoo their home.

Right: A bronze bust of Chief Seattle (or Sealth) stands in Pioneer Square.

Far right: This cast-iron pergola has been a fixture of Pioneer Square since 1909.

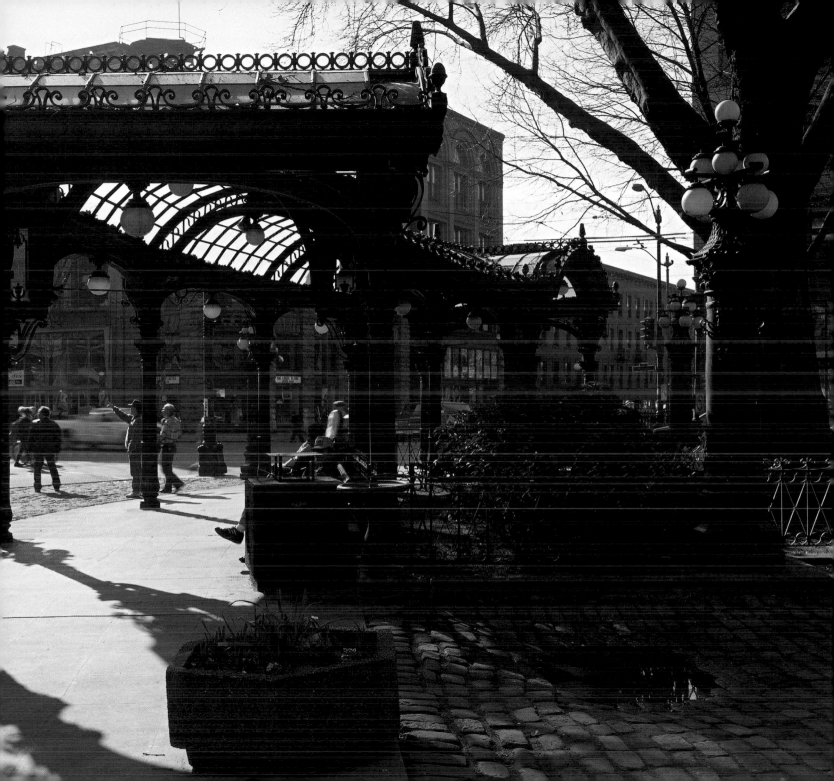

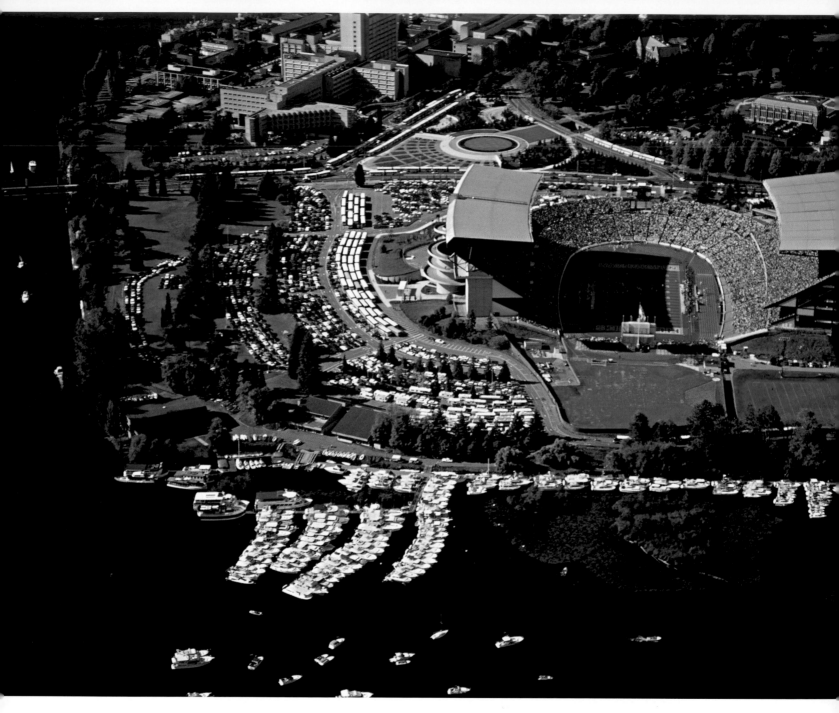

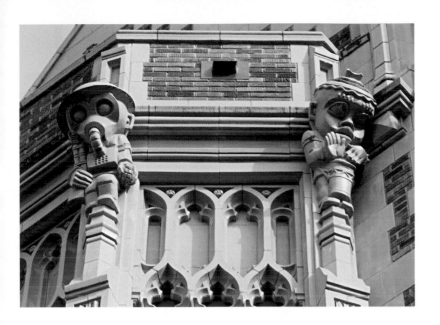

Left and below: Gargoyles dating from the 1940s adorn Smith Hall on the University of Washington campus. Dudley Pratt carved the original 28 gargoyles, which represent different aspects of local, national, and world history. In spring, delicate pink cherry blossoms complement the stone architecture of Smith Hall and the other buildings on the Liberal Arts Quadrangle.

Facing page: Built on Lake Washington in 1920, the University of Washington's Husky Stadium is one of the most scenic stadiums in the country.

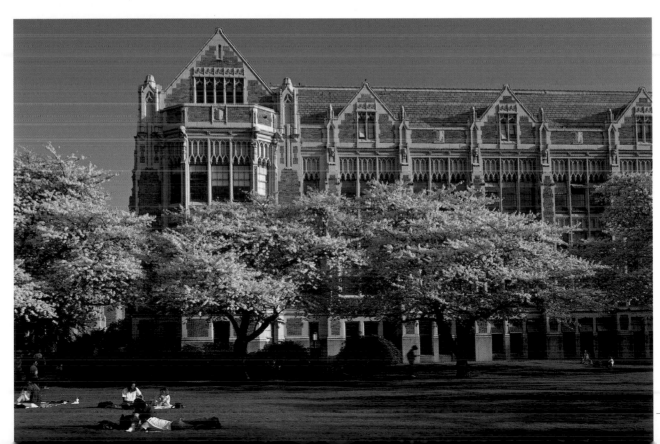

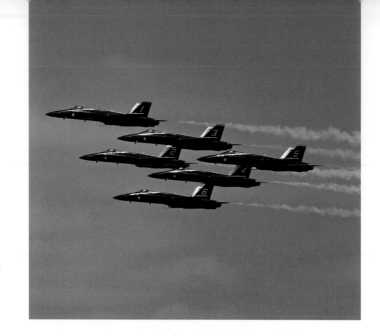

Right: The U.S. Navy Blue Angels leave spectators breathless with their show of high-speed precision flying at Seafair.

Far right: Sailboats ride the wind on Lake Washington, as seen from 300-acre Seward Park.

Below: Black Sun, a sculpture by Isamu Noguchi, sits at the lip of the Volunteer Park Reservoir.

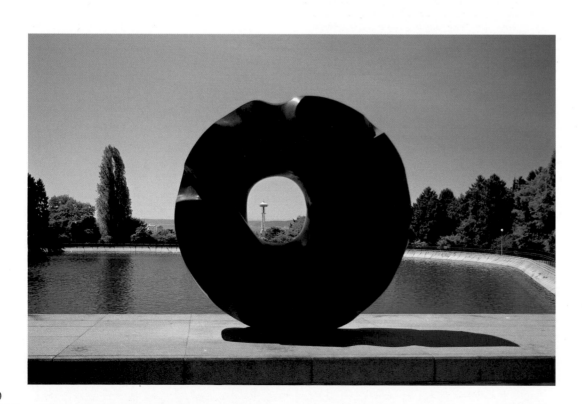

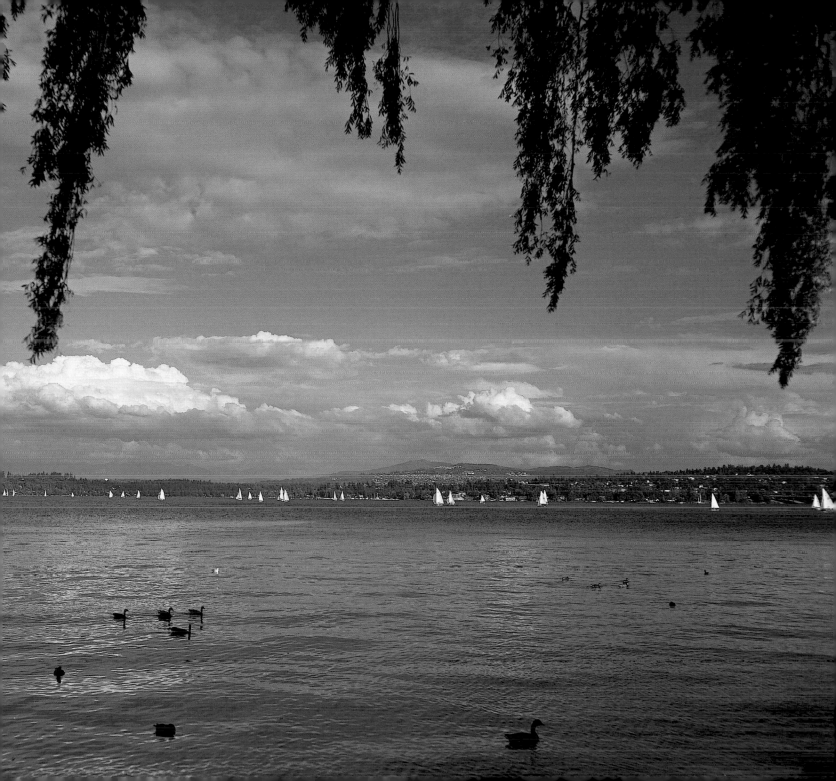

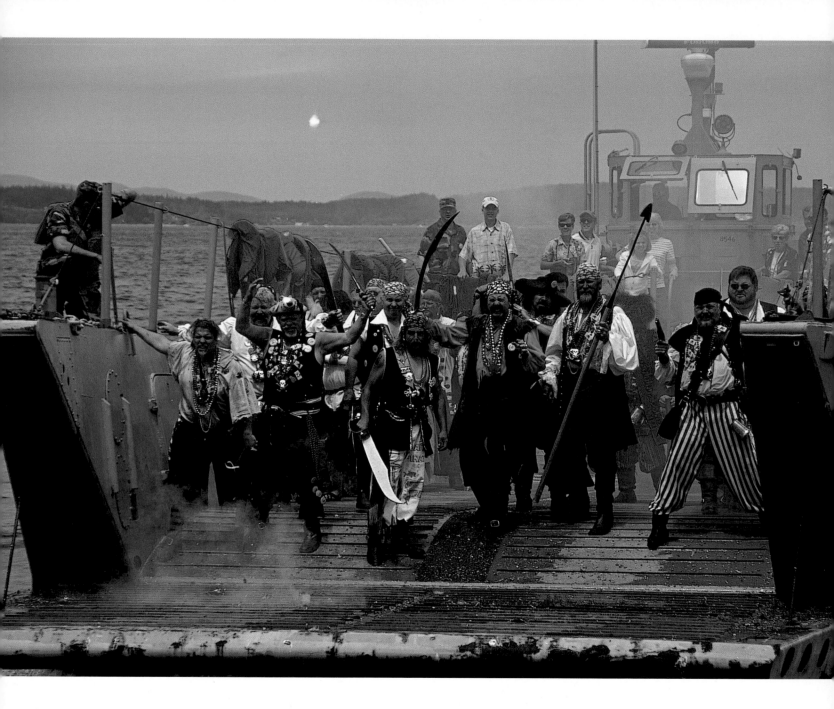

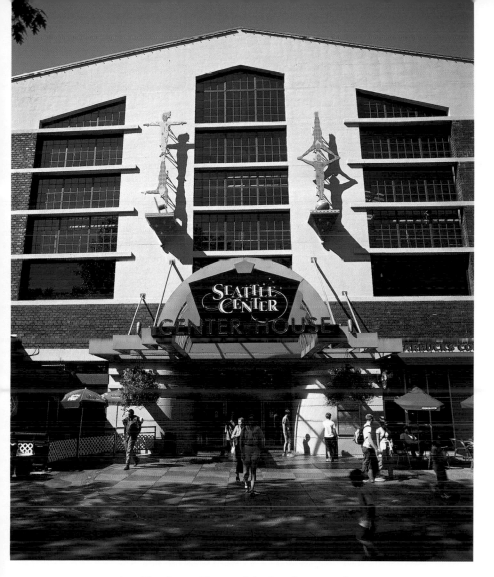

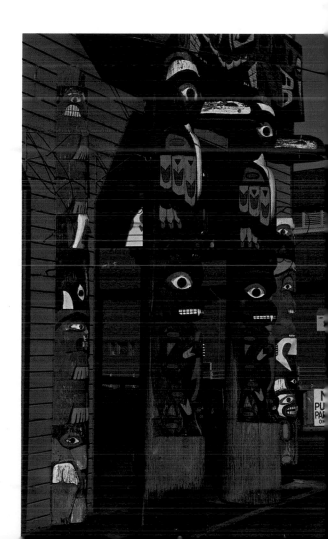

Above: The Center House of the Seattle Center features a theater, children's museum, food court, and The Center High School.

Right: Colorful totems mark the entrance to Ye Olde Curiosity Shop.

Facing page: The Seafair Pirates' mock invasion of Alki Beach kicks off Seafair each year. The group was formed in 1949 to raise money for a variety of charities and continues to do so today.

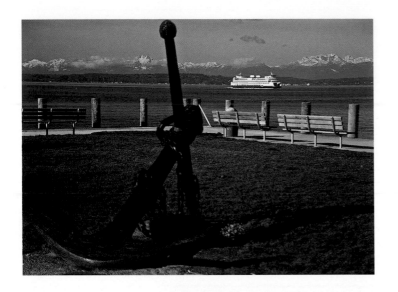

Left: A retired 2.5-ton anchor is displayed at Alki Beach.

Facing page: In addition to watching ships move through the Ballard Locks, guests can visit the dam and spillway, watch fish navigate the fish ladder, and tour the botanical garden and visitor center.

Below: In 1962, the city purchased this property—which was a plant that manufactured gas from coal—and converted it into Gas Works Park. The boiler house has become a picnic shelter, and the former compressor building is now a children's play area.

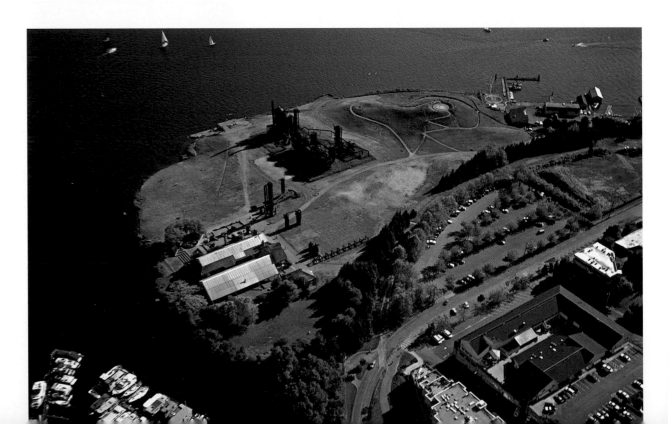

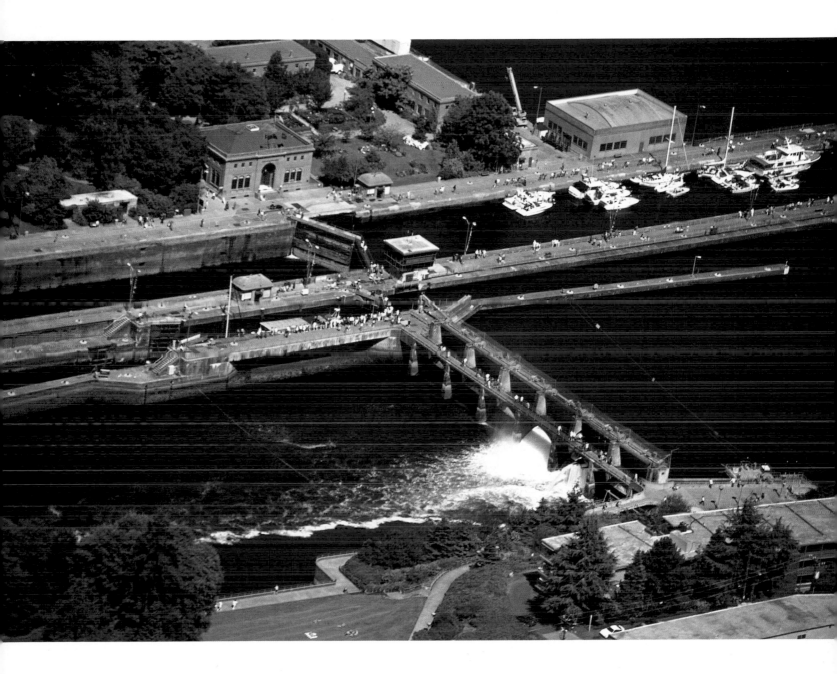

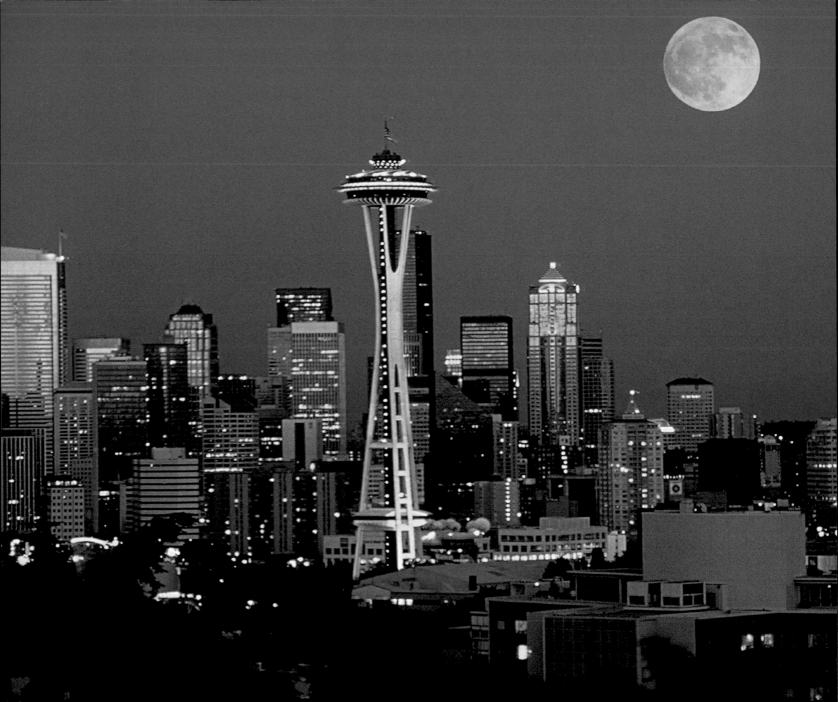

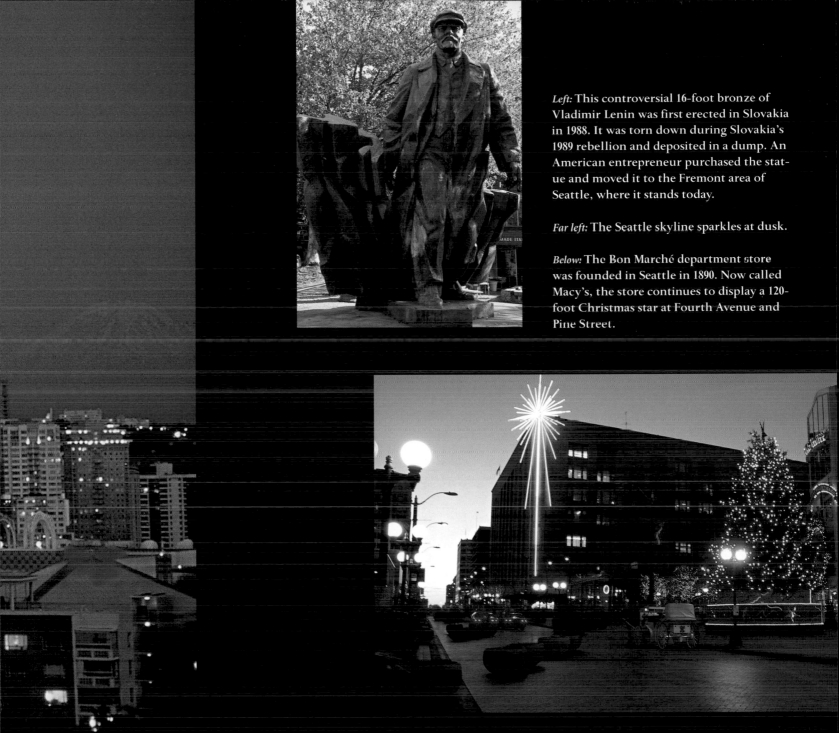

Left: This controversial 16-foot bronze of Vladimir Lenin was first erected in Slovakia in 1988. It was torn down during Slovakia's 1989 rebellion and deposited in a dump. An American entrepreneur purchased the statue and moved it to the Fremont area of Seattle, where it stands today.

Far left: The Seattle skyline sparkles at dusk.

Below: The Bon Marché department store was founded in Seattle in 1890. Now called Macy's, the store continues to display a 120-foot Christmas star at Fourth Avenue and Pine Street.

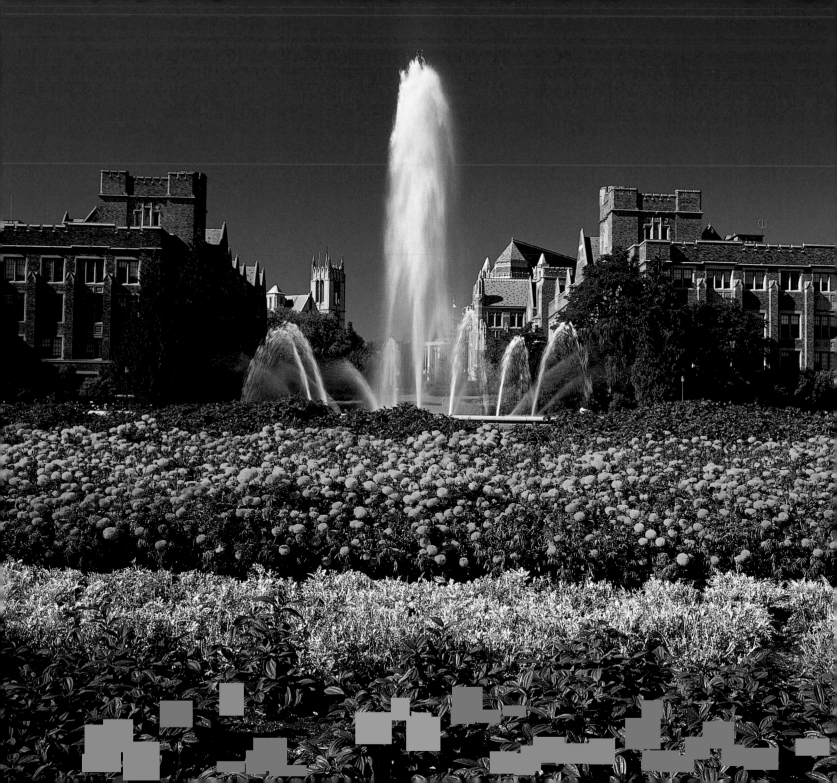

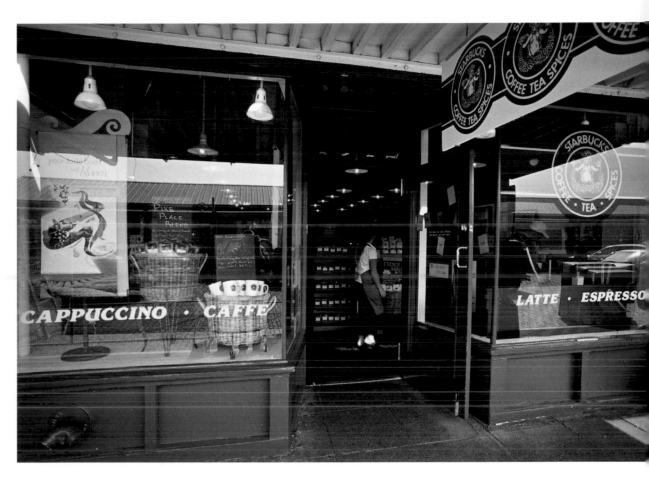

Above: In 1971, the first Starbucks Coffee shop opened at Pike Place Market. The successful chain now comprises thousands of Starbucks across the nation, with more than a thousand shops overseas.

Left: The University of Washington's Frosh Pond was built for the 1909 Alaska–Yukon Exposition. At its center is Drumheller Fountain, which was gifted to the university in 1961.

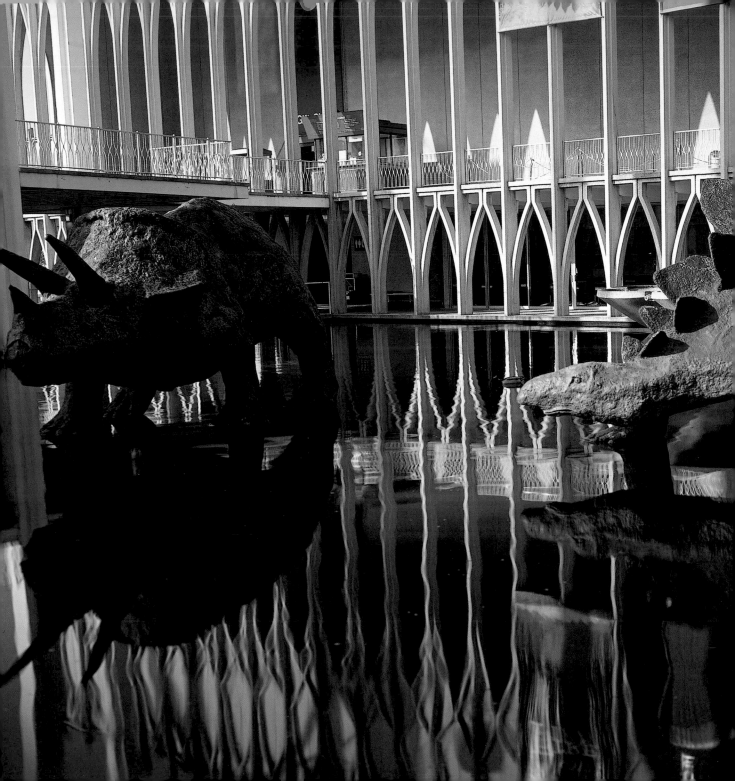

Left: These large dinosaur sculptures appear to walk on water at the entrance to the Pacific Science Center, located under the five white arches near the Space Needle.

Below: Sculptor Richard Beyer created Fremont's famed sculpture *Waiting for the Interurban* in 1979 of cast aluminum. It depicts five people and a dog, with a human face, waiting under a shelter for the bus. The piece commemorates the light rail line that once connected downtown Seattle and the surrounding neighbor-hoods. Citizens decorate the sculpture for a variety of events, including holidays and Husky games.

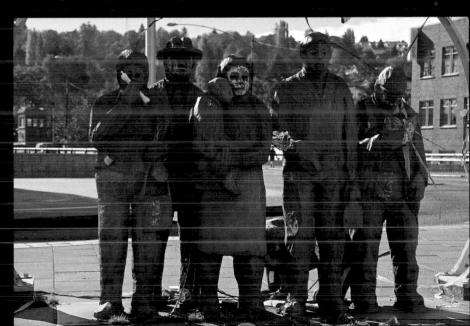

Right: Seattle has two floating bridges that connect Seattle with Bellevue and the East Side. Side by side, the two bridges span Lake Washington, with the Homer M. Hadley Memorial Bridge carrying westbound traffic from Mercer Island and the Lacey V. Murrow Memorial Bridge accommodating eastbound traffic to Mercer Island.

Below: During Seafair, the U.S. Navy, U.S. Coast Guard, and Canadian Navy show off their fleets to eager visitors. Pictured is the USS *Alabama*, a Trident submarine.

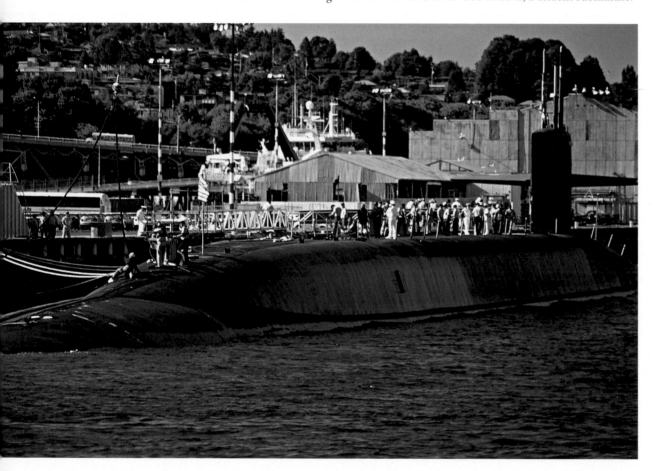

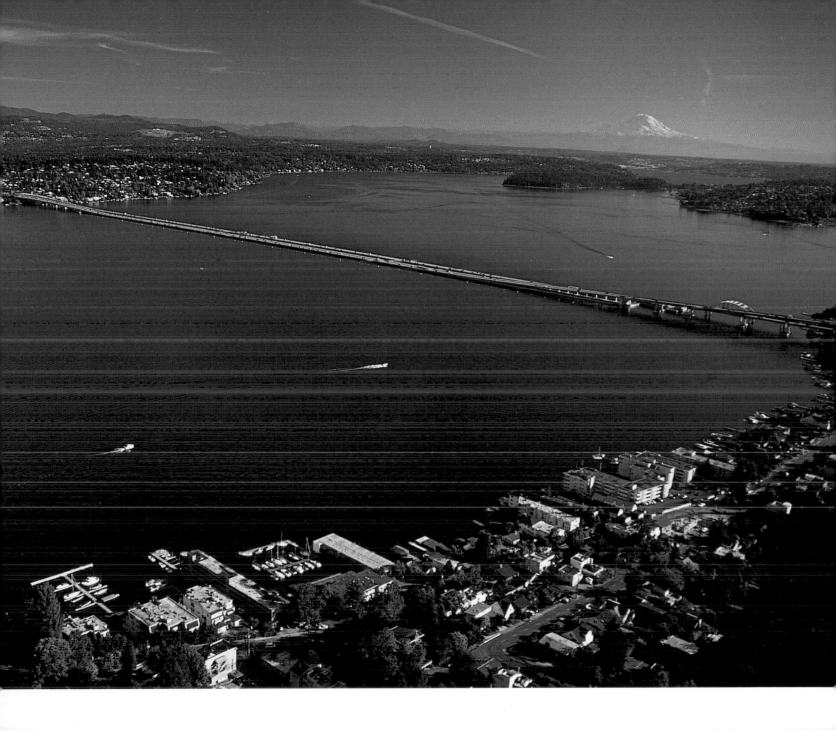

Right: The Seattle area's famed landmarks stand out in this aerial shot: note the Space Needle and surrounding Seattle Center, with the five white arches of the Pacific Science Center to the right; the Experience Music project to the left of the Space Needle; the tall black monolith of the Columbia Center at the top of the image; the arches of Qwest Field and neighboring Safeco Field in the right corner; Elliott Bay to the right; and Mount Rainier in the background.

Below: A troll lurks below Fremont's Aurora Bridge. His left eye is a hub cap, and he crushes a Volkswagen Beetle in his left hand. The Fremont Arts Council created the unique 18-foot-tall sculpture in 1990.

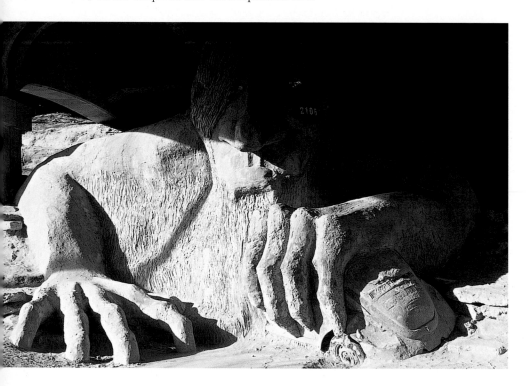

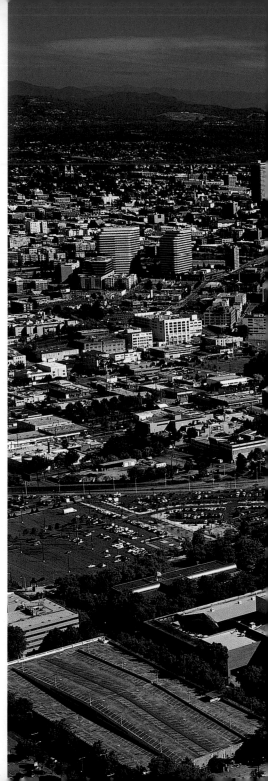

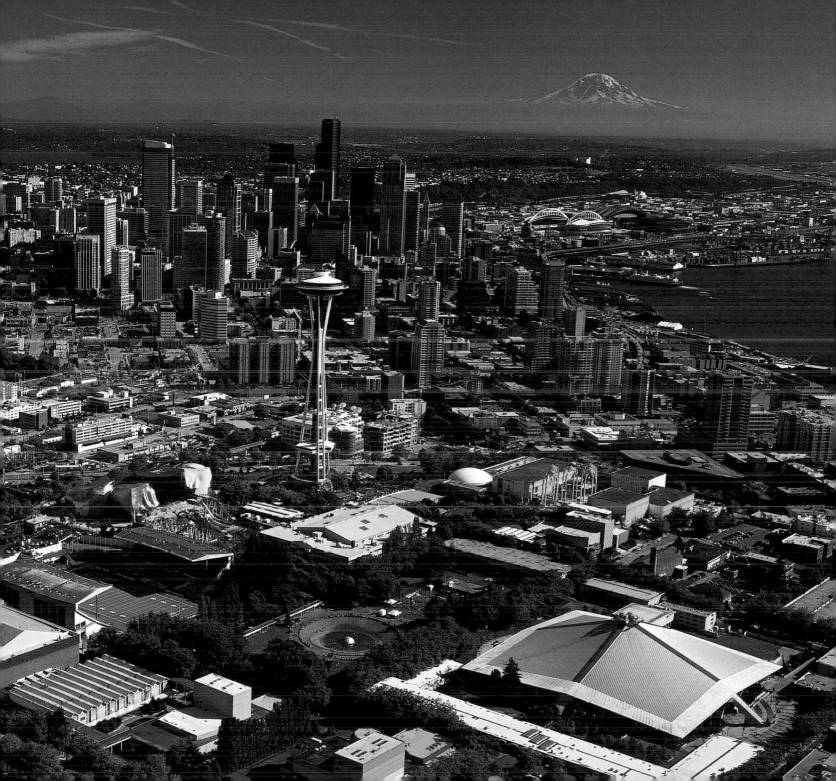

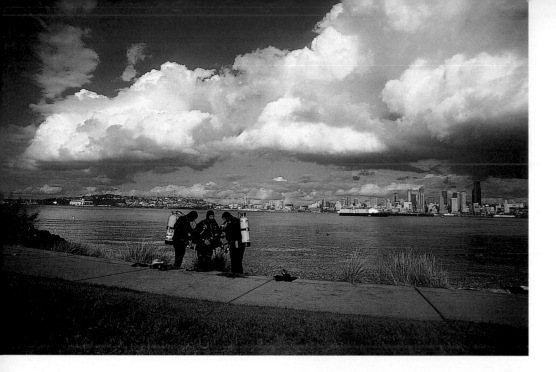

Above: Scuba divers check their gear before venturing out into Puget Sound near Alki Beach.

Right: The 467-foot Smith Tower was completed in 1914 but has been renovated several times since. At night, a large glass ball on top flashes the hour and quarter-hour with red, white, and blue lights. The legendary restaurant Ivar's appears in the foreground. Founder Ivar Haglund also once owned the Smith Tower.

Far right: A ferry cruises through Elliott Bay, with the snow-covered Olympic Mountains in the background.

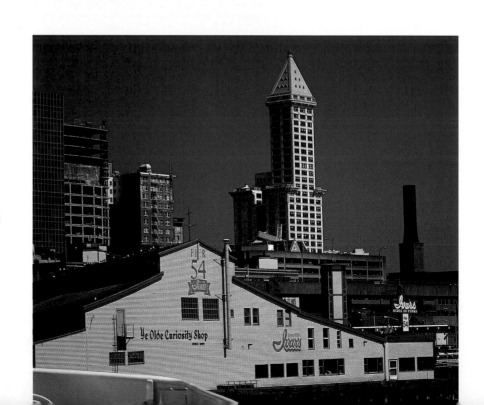

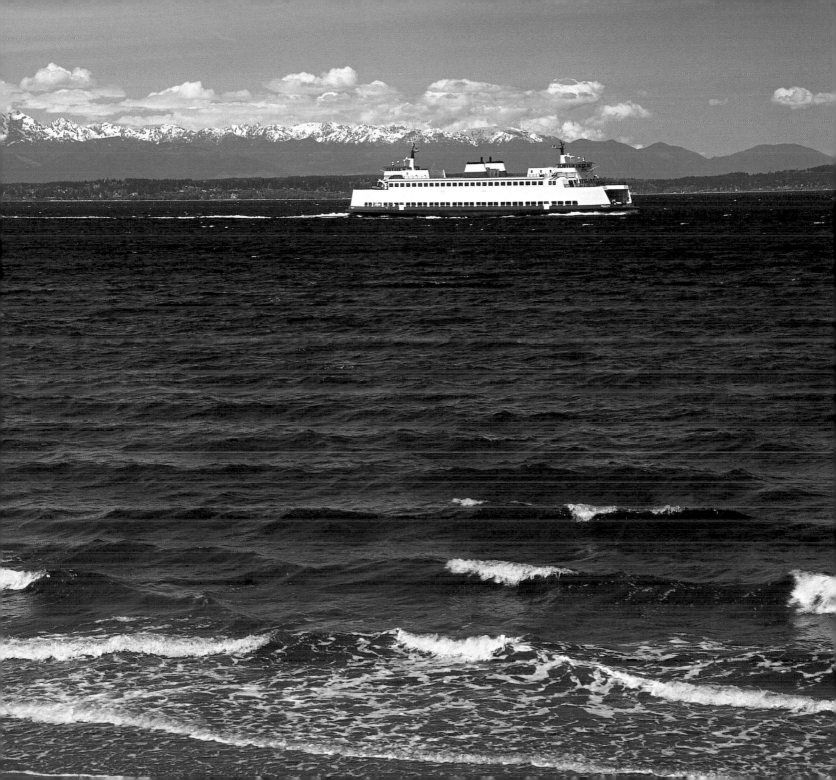

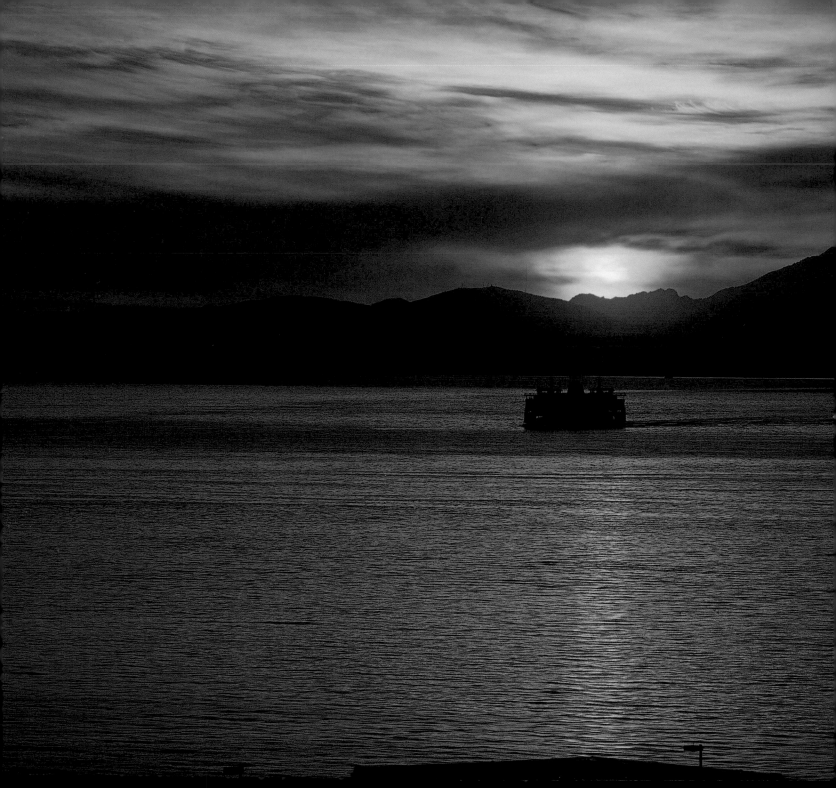

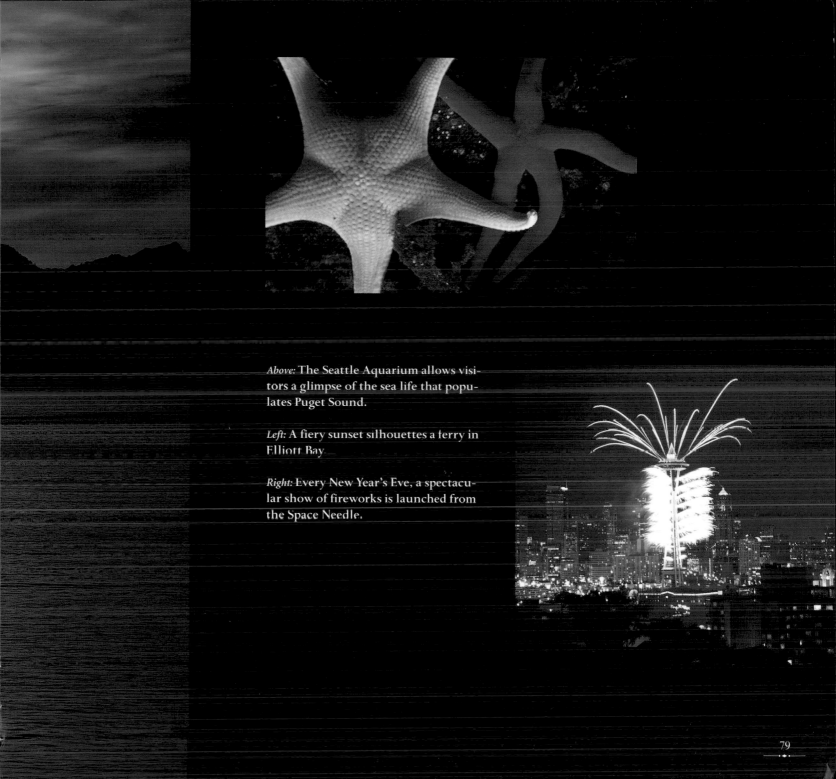

Above: The Seattle Aquarium allows visitors a glimpse of the sea life that populates Puget Sound.

Left: A fiery sunset silhouettes a ferry in Elliott Bay.

Right: Every New Year's Eve, a spectacular show of fireworks is launched from the Space Needle.

CHARLES ADAMS

Charles Adams is a 1954 graduate of the University of Washington. His photography hobby, which began twenty-five years ago, has turned into a successful career, and his photographs appear in postcards and calendars throughout the Northwest. Charles takes great delight in traveling the region and says, "There is beauty everywhere. The thrill is in seeing and being; the bonus is the ability to share images of these special places with the world."

www.ccadamsphotos.com